Painted Scrapbook Pages

Painted
Scrapbook
Pages

Create One-of-a-Kind
Pages with Simple
Painting Techniques

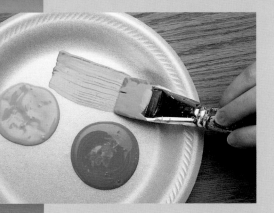

Melynda Van Zee

LARK BOOKS
A Division of Sterling Publishing Co., Inc.
New York

Library of Congress Cataloging-in-Publication Data

Van Zee, Melynda, 1971-
 Painted scrapbook pages : create one-of-a-kind pages with simple painting
techniques / Melynda Van Zee.
 p. cm.
 Includes index.
 ISBN 1-57990-774-1 (pbk.)
 1. Photograph albums. 2. Scrapbooks. 3. Painting. I. Title.
TR501.Z44 2006
745.593—dc22

 2006015066

10 9 8 7 6 5 4 3 2 1

First Edition

Published by Lark Books, A Division of Sterling Publishing Co., Inc.
387 Park Avenue South, New York, N.Y. 10016

Follow Your Bliss™ is a registered trademark of Joseph Campbell Foundation
(www.jdcf.org). It appears on page 87 by permission.

Distributed in Canada by Sterling Publishing, c/o Canadian Manda Group,
165 Dufferin Street, Toronto, Ontario, Canada M6K 3H6

Distributed in the United Kingdom by GMC Distribution Services, Castle Place,
166 High Street, Lewes, East Sussex, England BN7 1XU

Distributed in Australia by Capricorn Link (Australia) Pty Ltd., P.O. Box 704,
Windsor, NSW 2756 Australia

If you have questions or comments about this book, please contact:
Lark Books
67 Broadway
Asheville, NC 28801
(828) 253-0467

Manufactured in China

ISBN 13: 978-1-57990-774-7
ISBN 10: 1-57990-774-1

For information about custom editions, special sales, premium and corporate
purchases, please contact Sterling Special Sales Department at 800-805-5489
or specialsales@sterlingpub.com.

EDITORS: Jane LaFerla &
 Suzanne J.E. Tourtillott
ART DIRECTOR: Kathleen Holmes
COVER DESIGNER: Barbara Zaretsky
ASSOCIATE EDITOR: Nathalie Mornu
ASSOCIATE ART DIRECTOR: Shannon Yokeley
ART PRODUCTION ASSISTANT: Jeff Hamilton
EDITORIAL ASSISTANCE: Delores Gosnell
EDITORIAL INTERN: Sue Stigleman
PHOTOGRAPHER: Keith Wright

Contents

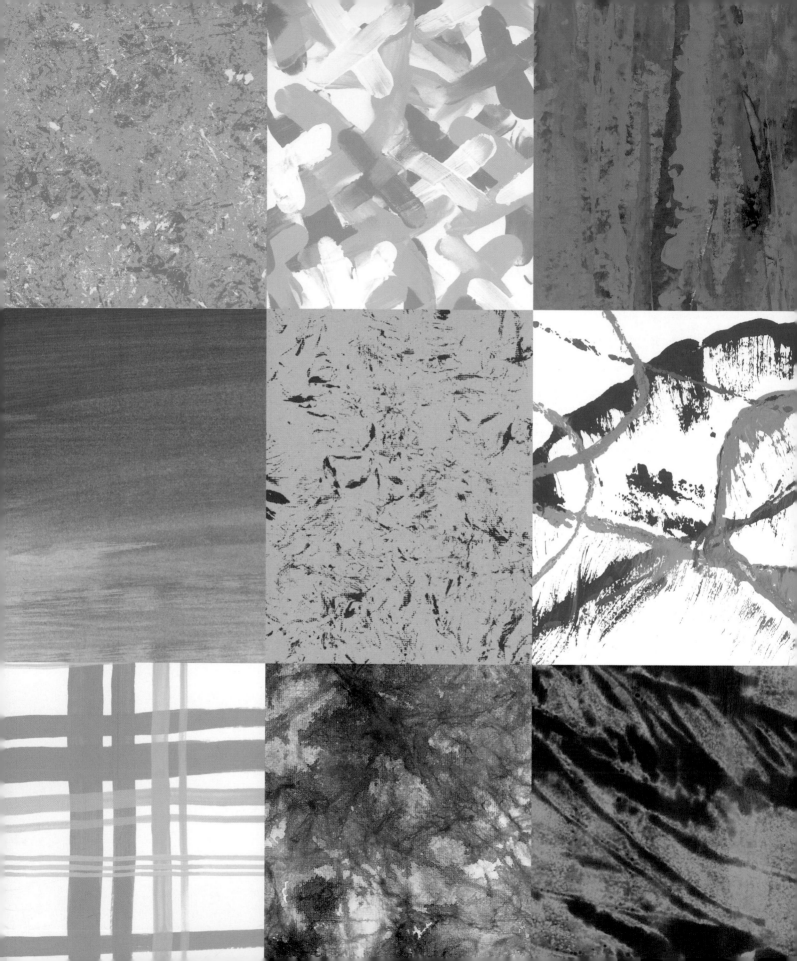

Introduction

I recently inherited one of the scrapbooks my grandmother made, which was stuffed full of photos and letters from all her grandchildren. Walking back through the pages, I found so many treasures—photos with her handwriting identifying each grandchild, letters I wrote her from my junior high years, and my wedding announcement. It made me think that just as memories are unique to each family, painted scrapbook pages are your own works of art, worthy of the stories your scrapbooks will tell.

I often tell people I was scrapbooking when scrapbooking wasn't cool. In fact, you could say I come from a scrapbooking family. I remember visiting my grandmother when I was a child, and how her scrapbooks spilled out of several baskets surrounding all sides of her living room chair. She would call me over, open a book, and begin the storytelling.

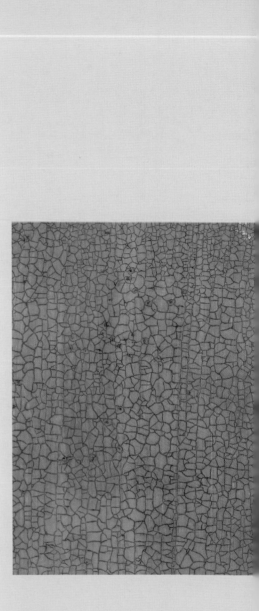

At our house, to keep me busy one summer, my Mom set me to gluing every birthday card we had ever received into the pages of a scrapbook. And I still have the first scrapbook I ever put together, a book documenting our family vacation to Washington, D.C. I kept scrapbooks during high school and throughout college. After graduating with my teaching degree, I began keeping scrapbooks of my students and many of our art projects. After the birth of my oldest son, the *new* interest in scrapbooking started to blossom. Suddenly, I discovered what I had been doing all those years had become a trend!

As an elementary and junior high school art teacher, I often taught scrapbooking and stamping classes on weekends at a local scrapbook store. A few years later, I was busy organizing and teaching art classes for our local community art center. My favorite class was teaching adults how to use a range of decorative techniques for painting their walls.

Looking back on my teaching experiences, it's interesting for me to see how I kept the two worlds of decorative painting and scrapbooking separate for so long. I scrapbooked and I painted—but never together—until one fateful day. After surviving a move that took me far away from my family and friends, I decided to reward myself by spending an entire week scrapbooking. I took out some paints and started experimenting. All of a sudden, simple dry-brushed lines and shapes decorated the first pieces of cardstock. Then, I grabbed some of my decorative painting tools. Soon, I found my watercolors and I was crumpling and wetting cardstock in the sink, water trickling down my arms.

After everything was dry, I started pulling out photographs. I was looking for the right photograph to coordinate with the color and feel of the painted papers I had created. Then, I looked for the story. What story did I want these pages to tell? The hand-painted papers and the scrapbook pages that resulted are some of the most satisfying pieces of art I have ever created. The unexpected journey to this book, *Painted Scrapbook Pages*, had begun. I hope

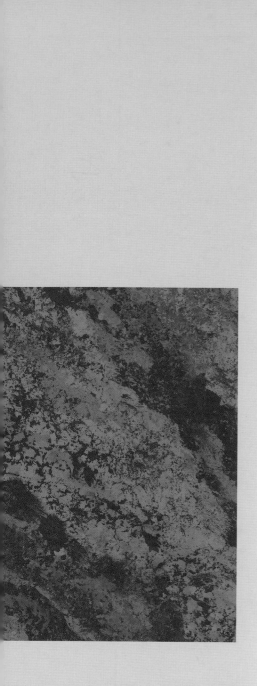

this book will lead you to find the same creative joy I have found in combining scrapbooking with painting. When you do, you'll discover that your pages can be much, much more than the ordinary *we-went-here-on-this-day* variety. The easy-to-learn techniques in this book will lead you to create your own mini works of art, and the scrapbook pages you'll make from them will be truly your own.

The techniques don't require any exotic art supplies that only a few scrapbookers might have on hand. Instead, the pages are made using simple tools, such as stencils, sponges, stamps, or decorative painting tools that you can find at any craft or home-improvement store. Many of the techniques are so easy that kids can even help with the creations. I urge you to try them, even if you don't think of yourself as artistic. Painted papers are meant to look handmade; any imperfections only add to their charm. As an art teacher, I always tell my students there really are no mistakes because some of the most wonderful surprises come from them. With this book I hope you'll find that any missteps you make are just opportunities to be more creative than you imagined you could be.

How to Use This Book

The Basics will walk you through the tools and materials you'll need to create painted papers. In It's All about the Tools, you'll learn easy paint techniques that use basic craft tools. (And some unexpected ones as well.) Just Brush It delves into the beautiful papers you can create with a brush and paint. You'll learn the basics of watercolor painting, drybrushing, painting plaids, blended strokes, and salt painting—you'll even find techniques for simple lettering ideas, for titles and journaling.

In Paint à la Faux, you can experiment with basic faux-finish techniques, such as sponge painting, rag rolling, marbling, and crackle. And don't forget to look for innovative designs created with masking tape. The final chapter, Off-the-Wall Techniques, will help you throw caution to the wind and create unusual painted backgrounds made by finger painting, crumpling paper, or pressing plastic wrap. Prepare for the unexpected!

In each chapter, you'll find tips and suggestions that will help you as you follow the instructions. Each painted paper is shown in a full-color photo, and some techniques have how-to photos to guide you as you work. Many techniques offer variations, giving you even more ways to create great papers. Throughout the book, you'll find layouts created by a talented team of designers. Their designs are meant to inspire you to use the papers you create.

I've never been one who could just paint a room one color and walk away. No, I always needed to add that *little* bit more—faux finish a wall, stencil a design, or add some words above an entryway. I guess I approach my scrapbooking in the same way. I always find myself adding that bit more—experimenting with a new technique, splashing a bit of paint here or there, and continuing to search for a way to make the page uniquely mine. If you are on the same search, join me as we create painted scrapbook pages.

The Basics

Do you remember how much fun it was to finger paint as a child? The feel of the paint on your hands, mixing the colors as you went, the satisfaction of the bright colors looking back at you? I remember the easel in my kindergarten class with the big glass jars of rainbow-colored water. I was ecstatic whenever it was my turn to paint. It didn't matter that the paint ran, it didn't matter that my fingers got dirty—all that mattered was that I was painting!

As adults we seem to second-guess all of our creative endeavors. Why do we think we must know the outcome before we allow ourselves to try? When we were in kindergarten we didn't stop to analyze the process, we just did it. But somewhere along the way in our artistic development, we stopped allowing ourselves to play. If you've ever said to yourself, "Anyone can do it except for me," or, "I'm not creative," or, "I can't paint," or, "I'll just make a mess of it," I have a challenge for you.

Look through some of the fun projects I've shared with you in this book, pick two or three that pique your interest, and just try them. Don't let your inner critic get in the way by telling you you're all grown up now and you really can't do it. After all, it's just a piece of paper and a bit of paint. Keep in mind that paint has a way of working its own magic— whether you're a kindergartener or an adult. What you make might surprise you, and you just might have more fun creating than you've had in a long time.

Toolkit ✔
Paint ✔
Brushes ✔
Paper ✔
Ideas ✔

9

A Painting Toolkit

It's much easier to jump into a fun painting project if you have all your supplies together in one spot. By putting them in one container, you'll have a painting toolkit that's ready to go at a moment's notice. Many of the supplies you'll need for the projects in this book can be gathered from your kitchen cupboards, junk drawers, and craft-supply box.

Besides brushes, paint, and basic faux finish tools, you'll want to include a variety of miscellaneous supplies—nothing fancy here, just a few odds and ends to make your work easier. Select a container for water— an empty yogurt container, plastic butter tub, or a plastic drinking cup will work.

Throw in a polystyrene foam plate, paper plate, or large plastic lid to use as a paint palette. A roll or stack of paper towels is an indispensable tool. I also keep a thin plastic tablecloth folded up in my toolkit. When I get the urge to paint, the tablecloth provides a handy cover for any surface (newspaper works, too).

Don't forget to pack your kit with some unusual tools as well. Pieces of string, fake credit cards, and marbles can help you make colorful and creative papers. Raid the kitchen cupboards for table or rock salt, old rags, plastic wrap, square sponges, and dish scrubbers.

Paints and Brushes

Get ready to create your own personal rainbow. With paint and brushes you're on your way to making unique and colorful papers.

Paint is inexpensive, easy to use, and infinitely mixable. You can set it up just about anywhere, cleanup is quick (it's nice to have a sink nearby), and with a few basic colors even you can be an artist.

The most versatile paint is good old acrylic craft paint—it comes in hundreds of colors and is available in every craft store. And don't forget watercolor. You can find it both in cake form (I can't resist those tin pans filled with color) and in small tubes. I have a particular weakness for round cakes of iridescent watercolor—they're perfect for creating shimmery effects.

As you peruse the paint aisle of your favorite craft store, you'll also find a wide variety of products that you can add to paint to give it special textural or finishing effects. You might want to select a crackle medium that creates a porcelain-china crackle effect. In the art supply aisle, you'll find gloss or matte gels that add dimension to paint. You might also want to buy a tube or two of gel or opaque paints to create lettering effects.

Brushes, brushes, brushes. How to decide? When you see row after row of brushes in an art or craft store, it's easy to feel intimidated. How do you ever pick the right brush for the job? How do you know what size, what style, and what handle length? You don't have to worry about any of that with the painting projects in this book. Many of them were done with a 2-inch (5 cm) trim brush, the same one you use when painting walls at home.

For the finer techniques, start your collection with one small and one large round brush, and a 1-inch (2.5 cm) flat brush. Don't pressure yourself to buy the perfect brush—just pick one. You can always upgrade to an even better brush when you've found the size you really like. When you're in the brush aisle, remember to select a palette knife, either made of plastic or metal. I like the kind with a bent handle and a pointed tip—a plastic butter knife will also work in a pinch.

Craft Store Supplies

There are so many great craft supplies that help make painting fun. Here are some tips to help as you stock up your painting toolkit with stencils, stamps, and faux-finish tools.

Stencils are available in a large variety of styles and themes. Stencils can be made out of cardboard or chipboard; but plastic, acetate, or metal stencils will last much longer for repeated use. If you're just experimenting, cardboard and chipboard are good choices because they're more economical.

Since words are important in scrapbooking, alphabet stencils are a great basic tool to stock in your paint kit. You'll want collections of small, medium, and large alphabet stencils. Keep your eyes open when shopping—you can find interesting stencils at craft, home-improvement, office-supply, and toy stores.

One word of caution about stencils: you'll find it can be frustrating when paint runs under them. (This usually happens to me during the middle of stenciling at the top of a wall while perched on a ladder.) However, I've finally discovered the secret to avoiding this problem—the paint will seem to glide over the stencil so much easier if the brush is almost dry and its bristles are soft. Use as little paint as possible when loading the brush, then make sure you tap or rub the brush on a paper towel to remove all excess paint before touching it to the stencil.

Stamps are great additions to any painting toolkit. You'll find they're versatile and will add personality to every project. Stamps come in thousands of designs, sizes, and shapes. You can purchase wood stamps, clear acrylic stamps, or oversized foam stamps. There are endless possibilities for using stamps on your scrapbook pages—or backgrounds, tags, or accents.

In addition to shapes, you can find great alphabet stamps with fun, new fonts. They're an easy way to add titles, journaling, and photo accents. If you can't find a stamp to fit your project perfectly, you can even make your own. For great stamped impressions that are also inexpensive to make, you can use bubble wrap, film canisters, rectangular art erasers, and even empty paint bottles.

Faux-finish tools should be an essential part of your toolkit. My favorites are a small roller brush, painter's masking tape (thick and thin), natural sponges, a feather duster, and a small plastic combing tool—I even keep a small square of sandpaper for distressing painted surfaces. While you can create many wonderful finishes with these few basic tools, you may want to investigate the amazing selection of faux-finish tools at craft and home-improvement stores.

Cardstock & Papers

There are many kinds of paper available, but not all of them are suitable for painting. For making painted scrapbook pages, you will use cardstock and watercolor paper.

Cardstock

You'll find cardstock in hundreds of colors and in different textures. As you experiment with a variety of textured and smooth surfaces, you'll find that each one will give you a different look.

Although it comes in several weights, using heavyweight cardstock is best. You can use lighter weights of cardstock, but they have a tendency to warp when you apply paint because the paper isn't strong enough to absorb paint's high percentage of moisture. If a paper warps after you have painted it, allow the paper to dry, then place it under a stack of heavy books. (I often use a few of my large scrapbook albums to weigh down a stack of painted papers.) Keep the paper under the books at least overnight before checking to see if it needs more time to straighten.

If you have a few sheets of cardstock that aren't in colors you like, don't throw them away. By adding other colors or applying paint to make a solid-color background, you can recycle what you have. This is a great idea for using all those odd-colored sheets in that multi-pack of cardstock you bought.

Watercolor Paper

Because it's acid-free, sturdy, and can hold larger amounts of water, watercolor paper has a great surface for making painted pages. Since the paper seems to easily withstand the trials of heavier use, I especially like to use it when I'm doing a watercolor-wash technique or for a project that requires using layers of paint. Watercolor paper is available in many different sizes and weights, but don't be intimidated by the choices—a 140-pound cold press paper works just fine. In order to tell if the paper is cold press, look at its surface. It will be textured with ripples that help to hold the water and paint; hot press paper has a smooth surface.

You can save money by buying big sheets of watercolor paper and cutting them yourself to the standard scrapbook page of 12 x 12 inches (30.5 x 30.5 cm). I like to purchase an oversize pad of watercolor paper and tear off the sheets as I need them. If you're experimenting and don't want to buy an entire pad, simply purchase a few individual sheets.

Choosing Colors

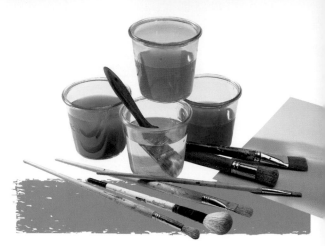

One of the most frequent questions I'm asked is, "How do I decide what colors to use?" There are about as many answers to that question as there are paint colors. If you struggle with color choices, let me help you simplify the process by giving you several tips.

First, review your motivation for the project. Are you trying to match a color from a specific photo? Do you want to create a coordinating background to match a patterned paper you really like? Is there a certain mood you want to convey with your layout?

Decide if you want your main color to be a warm color (red, orange, or yellow) or a cool color (blue, green, or purple), then select your paint colors to match. Don't forget about the high contrast you can get from using just black and white. You can also get wonderfully striking effects by using only neutral colors, such as white, cream, taupe, brown, or gray.

Try experimenting with combinations of secondary colors. These are simply the colors you make when you mix any two primary colors. You might find that purple, green, and orange make a pleasing color palette. You can also work with different hues of the same secondary colors—purple, green, and orange can easily become lavender, sage, and salmon. Pastel colors (pink, lemon yellow, and baby blue) create a soft and romantic look. Light blues and soft greens present a quiet and reflective tone. Vibrant, high-intensity colors like hot pink, turquoise, or yellow can create bright, cheery, or bold moods. Jewel tones

(burgundy, purple, and evergreen) add a depth of rich feeling to your project.

Using a photo or patterned paper for your inspiration is a great way to simplify choosing colors. Simply decide which colors you want to emphasize. For example, if the primary subject in the photo is wearing a red shirt, you may want to focus on matching the red. You could make it a monochromatic (one main color) background, or you might want to add elements of blue and yellow to create a background that features the three primary colors (red, blue, and yellow).

A monochromatic background is easy to make. Using the above example of emphasizing the red shirt, just pour three pools of red paint onto a paper plate, and mix a bit of white in one pool and a bit of black in another, leaving one pool pure red. Now you have three coordinating colors to use for the background paper. Adding more or less water to your paint colors will also result in different effects.

If you're still at a loss for a color inspiration, look all around you—you may find it in a favorite shirt from your closet, an advertisement, or a page from a decorating magazine. Look for colors that make you happy and are pleasing to your eye. It's really not hard, and the result will be a beautiful hand-painted page that is a reflection of who you are and the colors you liked at that one moment in time.

Organizing Ideas

Getting your supplies organized and in one spot is one thing, but what about organizing your ideas? I keep a small file box with index cards next to my painting toolkit. When I paint with new color combinations, or I want to remember a color I used on a layout, I jot down the exact paint colors I used on a card. I might even dab on a bit of the paint for a quick visual reference. This system comes in handy when you want to coordinate elements on a painted page. And, if you decide to add paint to an embellishment later on, you can quickly pull out the index card and have an exact record of the color of paint you used on the background.

You might also want to think about starting what I call a junk-paint book. I have an old manila-page scrapbook album that my grandma was throwing out, but any type of blank-page book would do. Every time I have a bit of paint left in my brush, I simply open up a new page and clean my brush out by painting any extra paint on the page. I don't try to *make* anything—I just paint until the brush is dry. It's amazing how these experiments jump-start me into creating new color combinations and patterns.

You Can Do It!

Painting creatively is not an exact science. There is no right or wrong way to do it. If you don't like your creation, add more paint layers, position a photo over the small area that didn't turn out just like you wanted, or try again.

Don't let your paint sit in the bottles gathering dust. Open a few of your favorite colors, squeeze them onto a plate, and see what happens. Don't tell yourself, "Today, I'm making a masterpiece." Instead say, "Today, I'm going to *try* some painting." When the mood hits me, I paint several backgrounds in one sitting. Then I have a supply of my own painted backgrounds all ready to go the next time I sit down to scrapbook—no need to even wait for the paint to dry.

The best advice I can give for getting started is to put on a little music, find a piece of paper, plant your feet under the table, grab your painting toolkit, and remember...it's *just* paint.

It's All about the Tools

Time to grab your toolkit and get busy. In this chapter, you can start making exciting painted pages using some of the tools you learned about in The Basics. Remember, tools don't necessarily have to be those you purchase at a craft or home-improvement store— some of the best ones can be found in junk drawers or recycling bins. Caution: You'll find that you might just get addicted to using everyday house- hold items as tools—if you do, you may want to warn your family that everything around the house is fair game when inspiration strikes.

Stencils ✓

Stickers ✓

Stamps ✓

Stencils

You don't have to be a pro with a brush to get that cool painted look you want—just stencil it! You can use lettering stencils, mesh, stickers, or precut plastic stencils for your background papers. You can even make your own stencils with simple tools found around the house.

17

Lettering Stencils

In scrapbooking, lettering stencils allow you to create many different looks from one simple stencil. You can easily add any name, word, or large monogram to a background paper. Try using a jumbo 6-inch-tall (15.2 cm) stencil that you can purchase at a home-improvement store, or see if you can find your old pocket-size book of stencils from elementary school. For a different look, as shown in this project, outline the stencil by brushing paint out from its edges.

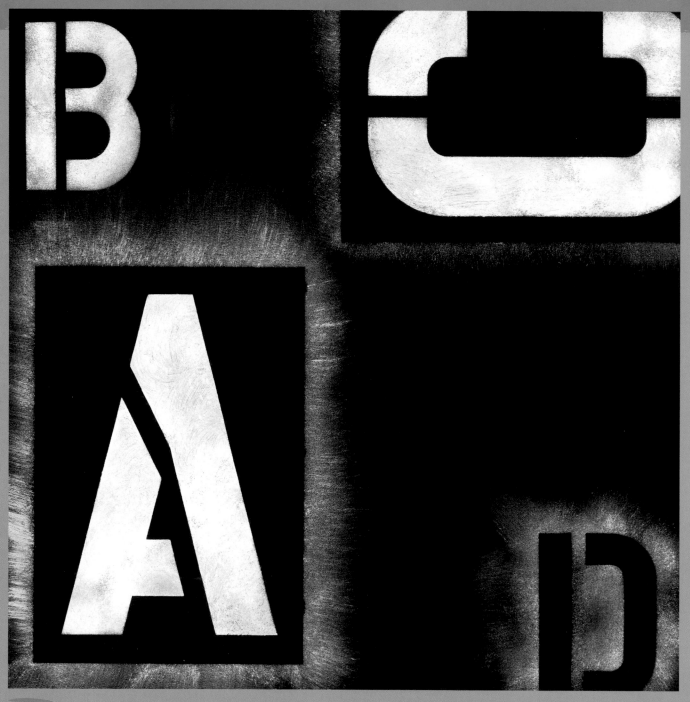

Materials & Tools

White acrylic paint

Foam plate or plastic lid

Stencil brush

Paper towels

Alphabet stencils

Black cardstock

Instructions

1 Squeeze the white acrylic paint onto a small polystyrene foam plate or large plastic lid. Lightly tap the stencil brush into the paint. Wipe or tap the brush on a paper towel to remove all excess paint. You want the brush to be almost dry to prevent the paint from bleeding under the stencil.

2 Lay a letter stencil on the black cardstock. Begin applying the paint by first brushing along the inside edges of the stencil, then use a gentle up-and-down tapping motion to fill in the center.

If you want the outline of the stencil to be visible, brush out from the edges of the stencil (see photo below). When finished, carefully lift the stencil away from the paper and allow the letter to dry.

3 Continue to add more letters as desired to the background paper, being careful to avoid laying the stencil over wet areas of the design. You can use a small personal fan to speed up the drying time. This comes in handy when you're stenciling letters close to each other.

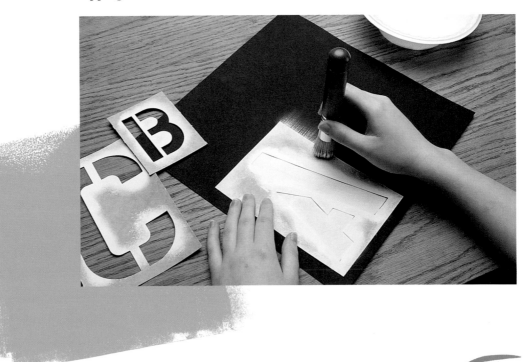

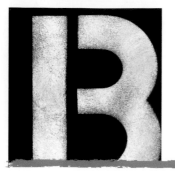

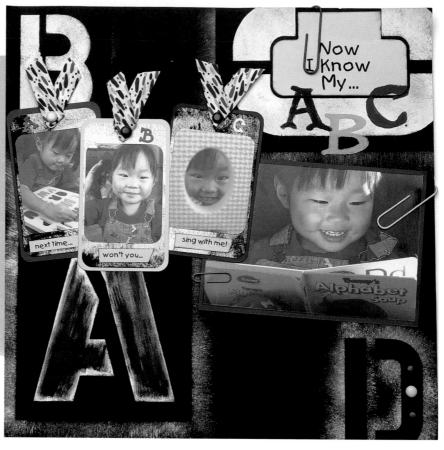

Adding touches of primary color to a black and white background paper is a great way to create a focal point for your page. By drybrushing red paint on the large stenciled A, designer Rita Shimniok draws your eye into the layout. The bright spots of red placed around the page coordinate wonderfully with the child's red shirt.

Rita Shimniok

STENCILING EXTRAS

To add even more interest to a stenciled background paper, incorporate the actual lettering stencil as an element when laying out the page. Use a flat brush loaded with a small amount of paint to highlight the inside edges of the stencil. Try adding a dark and light color for a dramatic effect (see the photo on page 69).

Make Your Own Stencil

Can't find the perfect size or shape stencil? No problem—make one yourself. You can cut chipboard or cardstock into any shape you can dream up. If you want to reuse a stencil, consider making it out of acetate or plastic (see Making Acetate or Plastic Stencils on page 23).

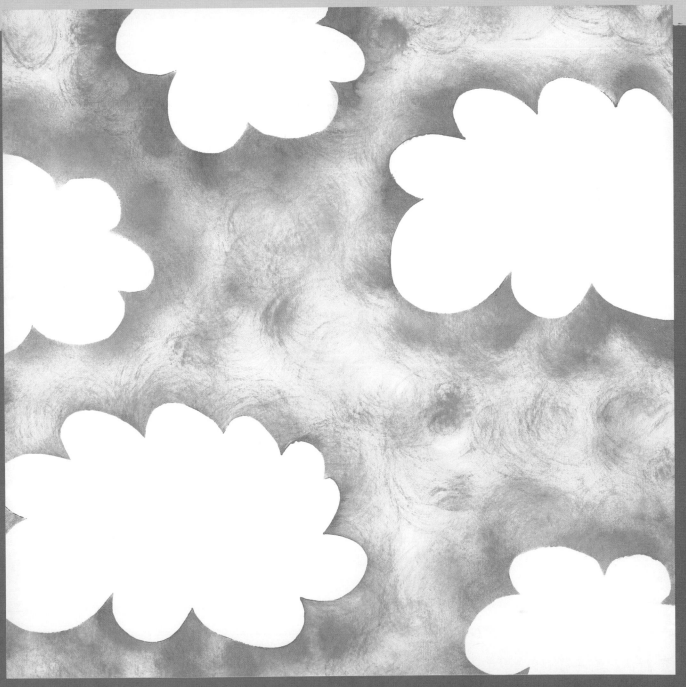

Materials & Tools

- Scissors or craft knife
- Chipboard or cardstock
- Permanent marker
- White cardstock
- Metallic blue acrylic paint
- Stencil brush

Instructions

1 To make the stencil, draw a cloud shape on a piece of paper. Cut out the shape, then lay it down on chipboard or cardstock and trace around the edges using the permanent marker. Cut out the stencil using a scissors or craft knife.

2 Place the cloud shape on a white sheet of cardstock.

Using a stencil brush, apply metallic blue acrylic paint around the edges of the cloud stencil. Add more clouds, allowing some to disappear off the edges of the paper.

3 When all the clouds have been completed, fill any open areas by swirling metallic blue paint with the stencil brush.

*U*p, *up, and away! Taking a cue from the rounded edges of the stenciled clouds and the swirling strokes of paint on the back-ground paper, the designer continues the light and airy look. Notice how she set the circle photos apart with a touch of color on their edges. And the title font is a perfect complement to the page.*

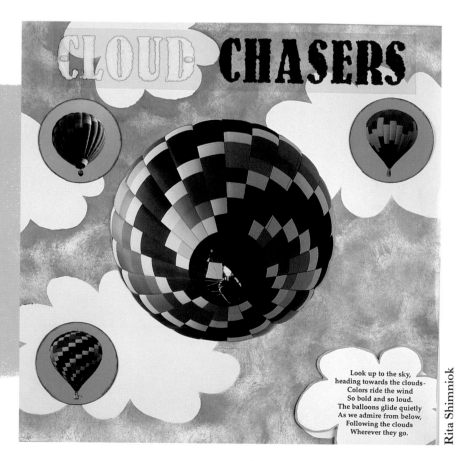

Look up to the sky,
heading towards the clouds-
Colors ride the wind
So bold and so loud.
The balloons glide quietly
As we admire from below,
Following the clouds
Wherever they go.

Rita Shimniok

Stenciled Landscape Variation

To create your landscape stencil, tear a piece of 12 x 12-inch (30.5 x 30.5 cm) cardstock in half. Try to tear the edge to make it look like a rolling horizon line. Position the stencil along the bottom edge of a piece of cream-colored cardstock. Load a stencil brush with a very small amount of green paint and stroke it over the edge of the torn stencil and onto the cardstock. Using different shades of green, as shown in the photo, move the stencil up the page, toward the middle, as you paint the layers of the landscape. To complete the top layers of the landscape, turn the cardstock page upside down. As you did with the green paint, use the brush to apply red and orange paint over the edges of the torn stencil, moving the stencil down, toward the middle of the page.

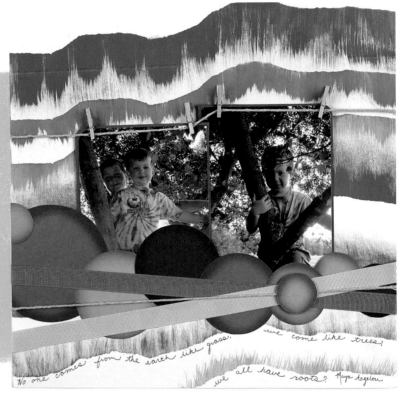

*T*ry combining your painted background paper with purchased patterned papers for a coordinated look. In this layout, I cut the circles from patterned papers and then overlapped them to make a border for tucking in the photos. The line created by the circles mirrors and highlights the flow of the stenciled landscape.

Melynda Van Zee

MAKING ACETATE OR PLASTIC STENCILS

You can build a library of your own favorite stencil designs. Acetate and plastic are strong and easy to clean, making them great materials for stencils that you'll use over and over. One inexpensive solution is to recycle the clear plastic sheets that are often included in packages of three-dimensional scrapbook stickers. After you peel the stickers off, just use this plastic backing.

To make your stencil, first draw your design on paper. Then, as shown in the photo, lay the acetate or clear plastic sheet over the drawing and trace the design with a permanent marker. Using a craft knife, cut out the design to finish the stencil.

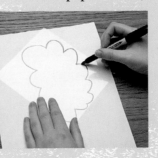

Mesh

The tiny squares in mesh or drywall joint tape will create beautiful textured papers. Applying one color, as shown in the photo, will give you a crisp grid-like pattern. If you want even more texture, don't be afraid to apply additional layers of color. Any surface with open holes, such as burlap or handmade papers, will also work well for this technique.

By sticking several strips of the drywall tape, side by side, directly onto your work surface, you can easily slide sheets of cardstock under the strips when you're ready to apply the paint. This works particularly well when you're making more than one paper at a time. Just remember, when cutting the tape strips, make them a bit longer than your paper.

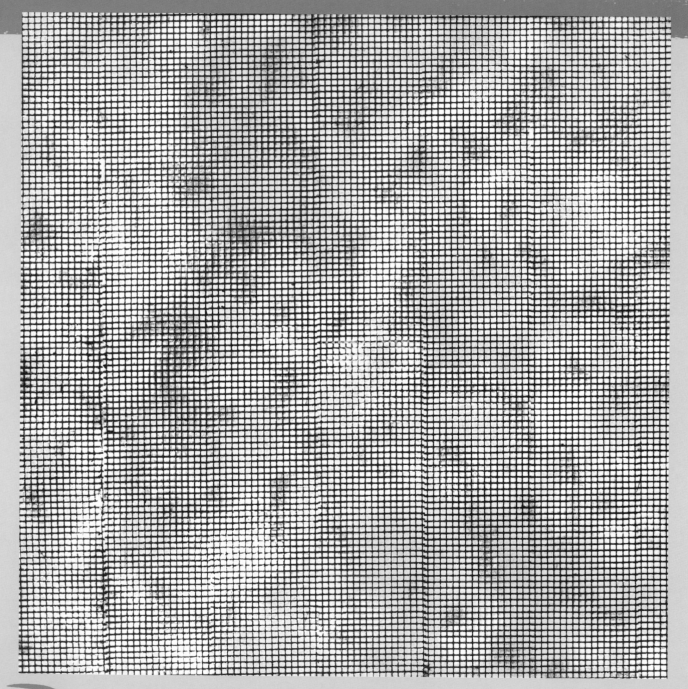

Materials & Tools

Drywall joint tape cut into 14-inch (35.6 cm) strips

Navy cardstock

Natural sponge

White acrylic paint

Paper towels

Instructions

1 Adhere the drywall strips to the work surface by pressing firmly along the top edges of the strips.

2 Slip the cardstock under the strips of tape, adjusting the tape if necessary.

3 Tap the natural sponge in the white acrylic paint and remove excess paint by tapping the sponge on a paper towel.

4 Lightly tap the sponge on top of the drywall tape, making sure that the paint goes through

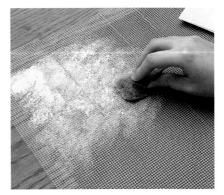

the holes (see photo above). You can lift a corner of the mesh to double-check the look of the texture. If you can't see the distinct lines of the pattern because the paint is running together, use a lighter touch and less paint. Reload the sponge as needed.

Using mesh as a stencil gives your painted page depth and texture. In this design, the papers for the tag and oversized initial letter of the title are made using the same stenciling technique. The red adds more depth while maintaining harmony with the background effect— your eye is never overwhelmed by too much pattern.

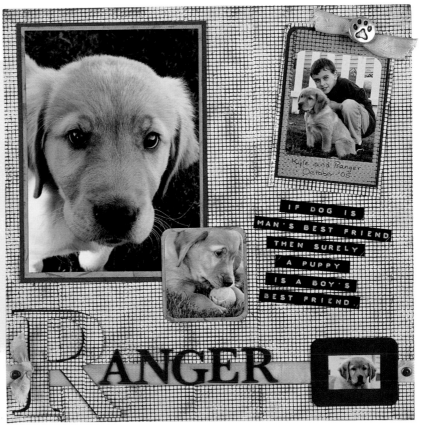

Rita Shimniok

Precut Plastic Stencil

You can find a precut stencil for almost any shape imaginable—from flowers to trucks to artistic motifs. You can use a stencil once on a page to create a beautiful painted accent, or you can repeat the motif as many times as you wish to create your own decorative patterned paper. Don't forget—the secret to successful stenciling is to keep the brush very dry.

Materials & Tools

2-inch (5 cm) and 1½-inch (4 cm) flat brushes

Orange, lime-green, and hot pink acrylic paint

Paper towels

White cardstock

Precut flower stencil

Stencil brush

Instructions

1 Load the 2-inch (5 cm) brush with the orange paint. Wipe the brush on a paper towel to remove all excess paint.

2 On a sheet of white cardstock, apply the paint in rectangular box shapes using a fast, sweeping stroke. Clean and dry the brush, then paint lime-green boxes in the same manner.

3 Load the 1½-inch (4 cm) brush with hot pink paint. Wipe the brush on a paper towel to remove all excess paint. Using quick strokes, apply the paint to the edges of the boxes to create highlights. Allow the paint to dry.

4 Place the precut flower stencil over the top of a painted box shape. Load the stencil brush with hot pink paint. Wipe the brush on a paper towel to remove all excess paint. Rub the stencil brush over the flower stencil. Reposition the stencil and continue to stencil more flowers as desired.

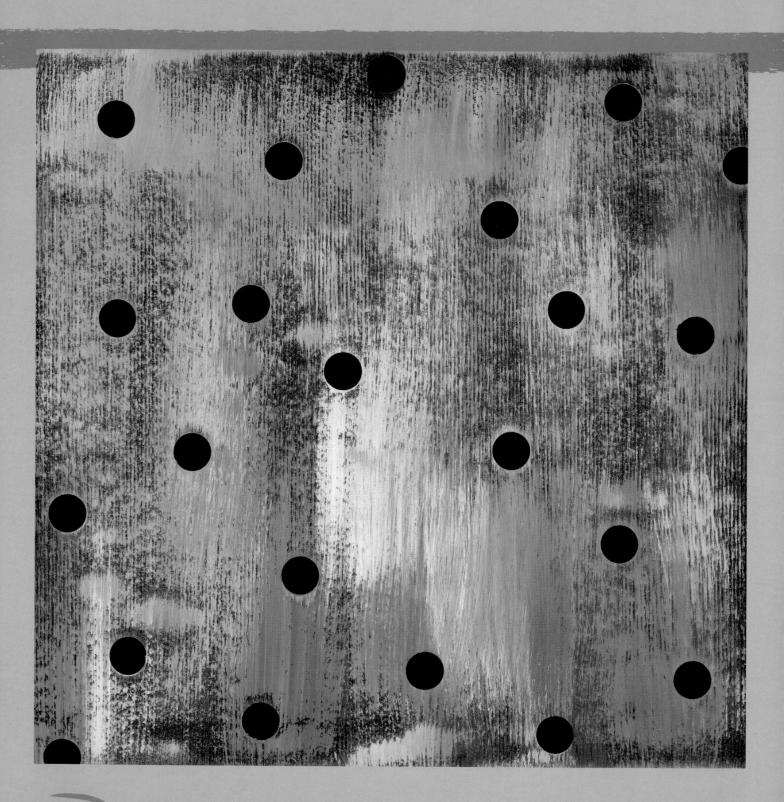

Stickers

Any type of sticker can be used to make a stencil, though the technique is the opposite of using a traditional cut stencil. A sticker will create a resist to the paint—wherever the sticker is, the paint won't go. Once the paint is dry and you remove the sticker, the outline remains.

Round stickers make fun polka dots, and star stickers make a great night sky. Long, straight stickers designed for scrapbook borders can also be used to create linear designs and patterns. Just remember to remove stickers as soon as possible or they will permanently adhere to the page.

Materials & Tools

Round stickers

Black cardstock

2-inch (5 cm) paintbrush

Pink and white acrylic paint

Paper towels

Instructions

1 Place round stickers randomly on a sheet of black cardstock.

2 Load the brush with pink acrylic paint. Brush off any excess paint on a paper towel.

3 Apply the pink paint to the paper in fast, broad vertical strokes. Clean the brush with water and dry it, making sure all water is out of the brush.

4 As you did in step 2, load the brush with the white paint, and paint in broad vertical strokes, filling in any areas without color.

5 When the paint is dry, remove the stickers.

Scrapbookers love stamps. Now you can use them to create your back-

Stamps

ground papers. As with stencils, you can use pre-made stamps or make your own. And if you're wondering what to do with all those stray items that end up rolling around in your drawers, try stamping with them.

For an instant stamp, poke the sharp ends of heart- or flower-shaped brads into a pencil eraser. Make stamps from film canisters, cookie cutters, forks, and other kitchen utensils. Carve an image in an art eraser. Or simply dip any found object into paint and stamp it on cardstock.

Most people think of using rubber stamps only with inkpads, but you can also use them with paint. If you're going to use paint, first select stamps without too many fine lines in the design—since paint is thicker than ink, finer details will blur when you stamp. Use a light touch when applying the paint to the stamp—this will prevent the stamp from sliding on the paper as you press down.

Foam Flower Stamp

Foam stamps are available in numerous designs or alphabets. In this technique, you'll apply the highlight color to the edges of the stamp before applying the base color. By blending the colors on the stamp, you can create a gorgeous artistic look that's perfect for flower motifs.

Foam flower stamp

Flat brush

Pink and orange acrylic paint

Pink cardstock

Instructions

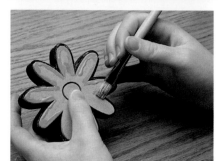

1 Turn the foam flower stamp upside down. Using the flat brush, apply the pink paint—the highlight color—only to the edges of the stamp.

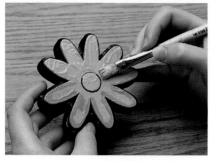

2 Apply the orange paint—the base color—over the entire stamp surface. The pink and orange will mix as you paint.

3 Press the stamp firmly to the cardstock. To get a good impression, apply even pressure with your fingers to the back of the stamp. Lift the stamp straight up.

Alphabet Stamps Variation

Use alphabet stamps to create this adorable baby paper. Load a large 2-inch (5 cm) brush with hot pink paint. Remove any excess paint by tapping the brush on a paper towel. Apply several broad strokes of the hot pink paint to a sheet of white card-stock. Next, use pink, hot pink, or red paint to stamp the words, as shown in the photograph.

Using a design concept known as the "magic of three" is a great way to tie the painted page and added design elements together. Notice that the painted title is repeated three times, that there are three photos, and that the two flowers and the painted heart create a visual triangle. The heart is made from painted and folded spun olefin, a material described in Folded Paper on page 113.

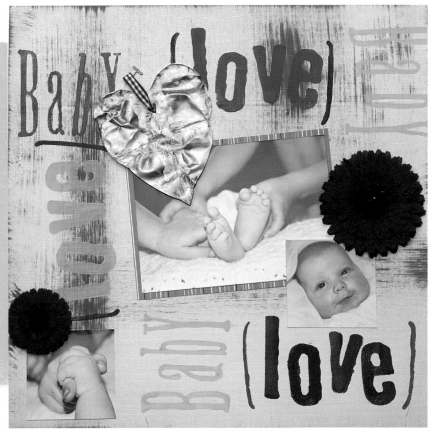

Melynda Van Zee

KEEP ON STAMPIN'

Stamping multiple impressions can add an illusion of depth to your finished design. Try using a stamp several times before adding more paint. You'll see that each impression will be lighter and lighter until you have a ghost image. You may be able to get up to three impressions before you need to reload with paint.

Rubber Stamps

The amazing variety of rubber stamps you can buy seems endless. You can use stamps that have decorative motifs to create papers or choose basic geometric shapes. For this paper, simple frame and box stamps are all you'll need to make this attractive border.

Materials & Tools

Foam brush

Pink, burgundy, and sage green acrylic paint

Rubber stamps, one each in box and frame shapes

White cardstock

Instructions

1 Using the foam brush and pink paint, lightly coat the rubber surface of the box stamp. Press the stamp firmly to the white cardstock. Lift the stamp straight up.

2 Reapply paint and stamp again in a different location on the cardstock. Repeat this step four or five times. Allow the paint to dry. Clean the stamp.

3 Again, using the box stamp, randomly stamp additional boxes on the border of the paper with burgundy and sage green paint as desired. Remember to let the stamped images dry between each application of a color.

4 Apply the sage green paint to the frame stamp. Press the stamp to the paper. Reapply the paint, and stamp again as desired.

The stamped squares on this painted paper do double duty. They not only make an interesting border, they also provide a great space for placing your design elements. You can journal in the squares or add word stickers, as shown in this layout. The clear plastic circles, attached with flower brads, are a quick way to add another layer of interest to the words.

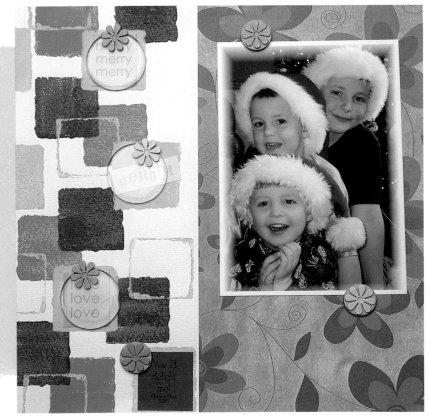

Melynda Van Zee

35

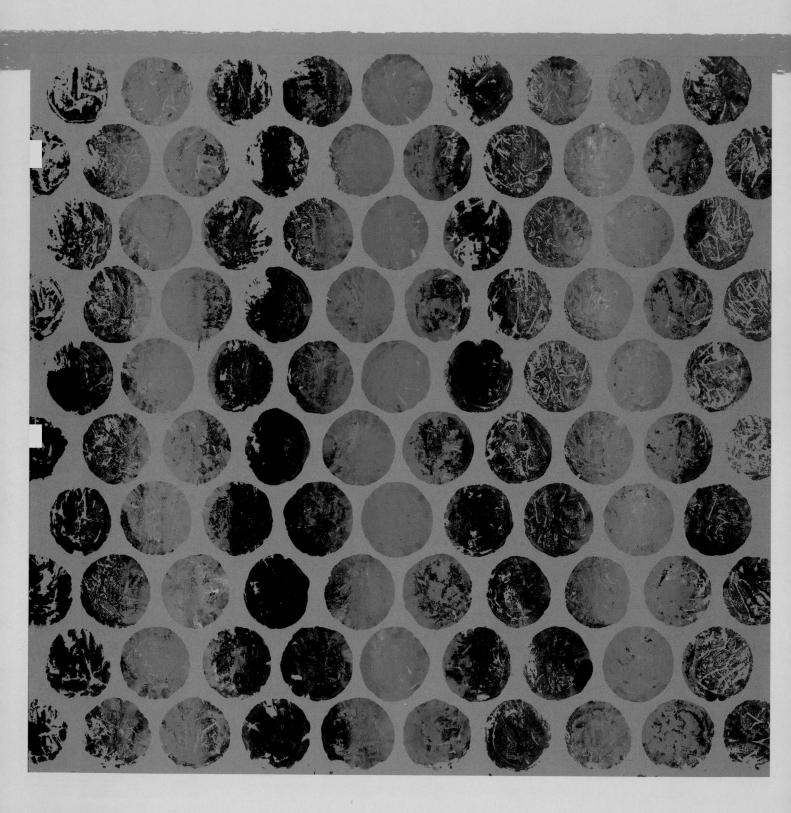

Bubble Wrap

Stop popping those bubbles and start painting. Who doesn't have fun playing with bubble wrap? But have you ever used it with paint? The bubbles in bubble wrap come in several different sizes. When painted and stamped, they make wonderful repeating, radial patterns. You can paint the bubbles one solid color, or use shades of the same color, as shown in the photo, to create a striped effect.

Materials & Tools

Foam brush

Light and dark purple acrylic paint

Sheet of large-bubbled bubble wrap

Lavender cardstock

Instructions

1 Using a foam brush, apply stripes of light and dark purple paint to the bubble wrap's surface.

2 Gently place the painted bubble wrap over the lavender cardstock. Firmly press the back of the bubble wrap with your hands, making sure all areas of the bubble wrap have come in contact with the paper.

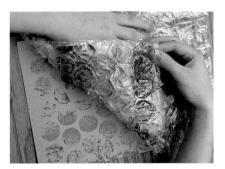

3 Lift and remove the bubble wrap.

The purple background paper was made using the bubble-wrap technique. The coordinating pink paper was made the same way, using wrap with smaller bubbles. The designer, Maranatha Baca, used this pink-stamped paper to create bright design elements for her layout. She repeated the rounded bubble shapes by incorporating other rounded edges throughout the design. Notice how the curved title wraps around the top corner of the photo.

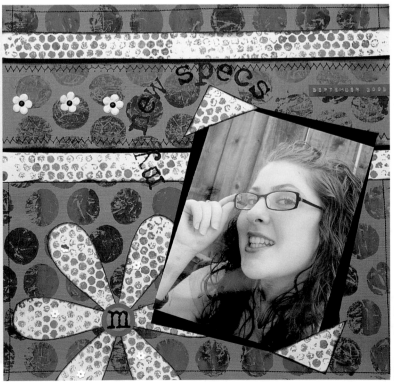

Maranatha Baca

Small Bubbles Variation

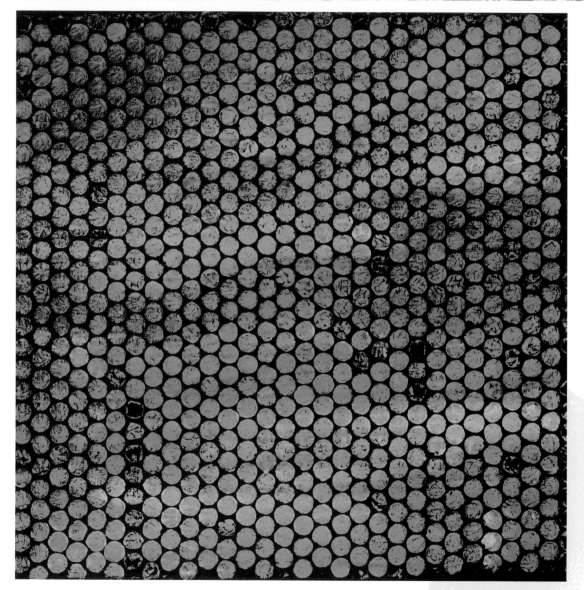

To make this variation as shown, first use a brush to apply pink acrylic paint to a sheet of bubble wrap that has medium-sized bubbles. Then, press the painted bubble wrap to a sheet of dark purple cardstock.

One Handy Stamp

A child's hand makes a perfect stamp. In this technique, you'll create a personalized handprint border for your page. It's great fun to create this project together with a child—while capturing the handprint, you might just capture some precious memories.

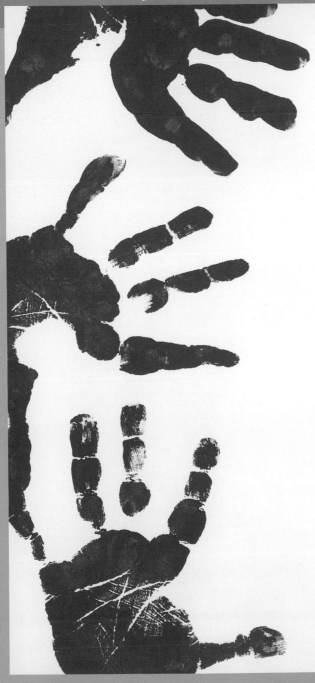

Green acrylic paint

Foam plate or plastic lid

Child's hand

Cream cardstock

Instructions

1 Squeeze a pool of green paint on a plate or plastic lid, then press the child's hand into it.

2 Lift the hand and press it firmly on the edge of the paper.

3 Make three impressions on the cream cardstock.

*M*ost likely, handprints were the first stamps. Drew's open hands in the photo provided the perfect inspiration for this paper, and I couldn't have done it without him. Notice how I balanced the layout by painting the chipboard letters the same color as the prints. Distressing the edges of the painted letters with sandpaper adds extra textural interest.

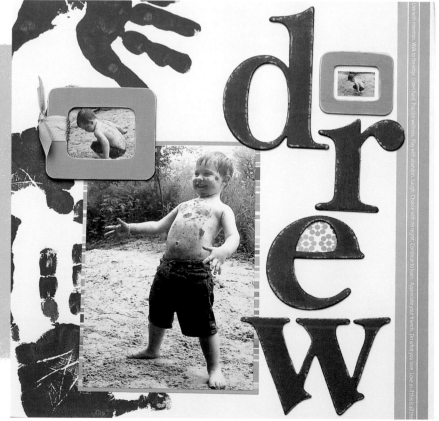

Melynda Van Zee

Circle Variation

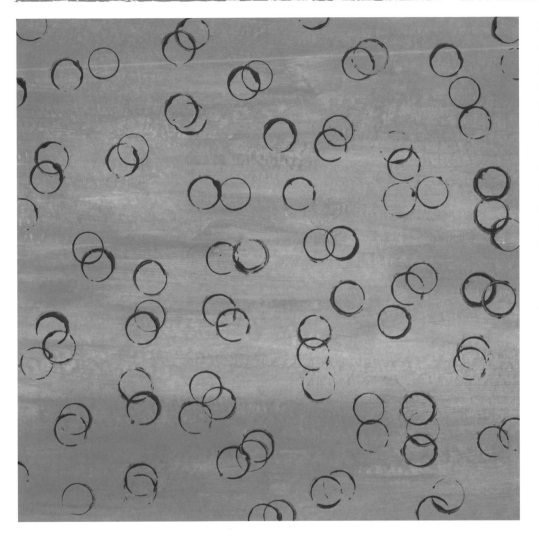

It's easy to add circles and dots to a background paper. Film canisters dipped in paint are great for creating the letter O in titles, or duplicating the look of bubbles. You can make tiny dots using a stylus or the end of a small paintbrush. Or, try making a larger dot pattern with a pencil eraser or a cotton swab. As shown in the photo, you can make circles by stamping the rim of an almost-empty bottle of paint directly on the cardstock.

THE THREE-MINUTE STAMP

All it takes is a few minutes to make an easy stamp. For the handle, use a film canister or an old credit card. For the stamp, trace any shape on a round cosmetic sponge or craft foam (see photo near right). Cut it out, then use double-stick tape to adhere the shape to your "handle" (see photo far right). Using a brush, apply paint to the new stamp before pressing it firmly to the paper.

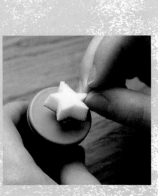

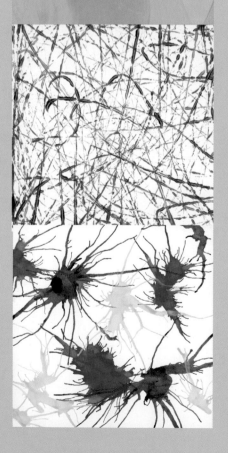

Not-Your-Everyday Craft Tools

Loosen up and get messy. Don't look for the standard craft tools when making these projects. Instead, let sample credit cards, straws, string, and even marbles do the work of making these wild designs. Remember to cover your work area with an old plastic tablecloth or plastic drop cloth— you never know where the paint might land with these super-easy techniques.

Scraping

You can create graceful, wavy painted papers by moving and scraping the paint over the page. Use a small plastic ruler or a sample credit card—the kind that comes free in the mail—as your tool. Simply squeeze a few drops of acrylic paint straight from the bottle along the top edge of the cardstock, then gently move the ruler or card back and forth as you pull it through the paint. You can use one color of paint or select two shades of a similar color as shown in this project. Because the colors combine as you pull and scrape the paint down the page, using two shades of similar colors creates a stunning tone-on-tone effect.

Materials & Tools

Teal blue and lavender acrylic paint

Light blue cardstock

Small plastic ruler or credit card

Instructions

1 Squeeze a few drops of teal and lavender paint straight from their bottles along the top edge of the cardstock.

Scraping paint allows you to make wonderful wavy lines, which I repeated throughout the layout. To frame the photo, I cut wavy-edge strips from purchased patterned paper to contrast with the straight lines of the tile paper. I wanted to draw the eye into the photo's unusual angle—it's like we're peering over their shoulders waiting to see what will be discovered.

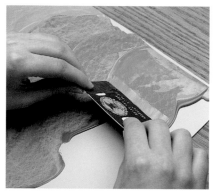

2 Pull the ruler or card through the paint, gently moving it back and forth in a wave-like motion as you pull the paint down the page. When you reach the

bottom of the page, wipe the excess paint from the ruler or card, and, starting from the top of the page, pull again. Keep in mind that the more times you pull through the paint with the tool, the more blended the final look will be.

3 If any areas of the page are missing paint and you wish to fill them in, squeeze more paint straight from the bottle, directly to the page where you need it. Pull the ruler or card through the paint until you have the look you want.

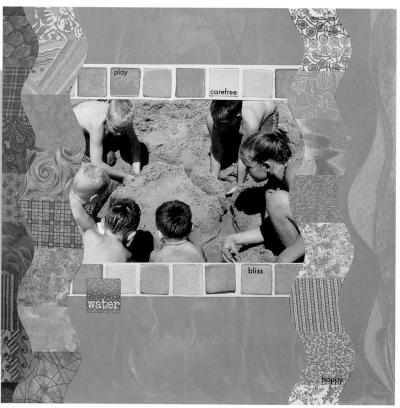

Melynda Van Zee

Texture Gel Variation

By mixing texture gel with paint, you can add new dimensions to your wavy-stripe patterns. Use a palette knife or plastic butter knife to mix the gel and paint. Then using the same palette knife, apply a thin coat of the paint mixture over the entire surface of a sheet of turquoise cardstock. Drag a small ruler or credit card down from the top of the page to the bottom, creating

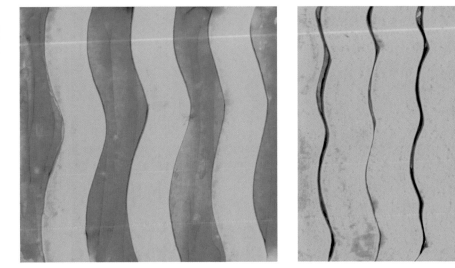

thick or thin strips as you pull. You may want to wipe the card off after each stroke. You can make straight lines, wavy lines, or diagonal patterns—the choice is yours.

Color Blocks Variation

You can create bold blocks of color by the way you drag the ruler or credit card on the paper. Place a small pool of maroon paint on your paint palette. Dip the edge of your small ruler or credit card into the paint. Drag the ruler or card across a sheet of cream cardstock, using short strokes to randomly cover the page.

Splattering

This technique is simple to do, but looks so artistic on the page. In fact, when you splatter paint, you just might feel like the Abstract Expressionist painter Jackson Pollock. He created huge canvases on the floor of his barn by flinging paint from one end of the piece to the other. Here's another incentive for trying this technique—you'll find that splattering is also a great stress reliever.

Materials & Tools

Lime-green cardstock

A box that's bigger than the paper

Small round brush

Pink, purple, and orange acrylic paint

Instructions

1 Place the lime-green cardstock in a box. You can also paint outdoors—I just lay my cardstock on the grass.

2 Using water, thin the pink acrylic paint to the consistency of milk before loading the brush.

3 Flick your wrist to fling the paint on the paper. Large arm motions create lines of bold color.

4 Take time to study the piece. Ask yourself where you might need to apply more color and in what direction it should go. As you did for the pink paint, add thinned purple and orange paints to complete the design.

TIP: If you want a finer, more detailed splatter pattern, load an old toothbrush with paint, hold it over the cardstock, and slowly rub your finger across the bristles of the brush. The paint will fall off the tip of the toothbrush to create fine speckles.

Blowing Paint

Try recruiting some kids to help you make this paper. All you need is a few drinking straws and paint. You'll be surprised at the fun you'll have and at the wild designs you can make.

Orange, black, and lime-green acrylic paint

Plastic spoon

White cardstock

Straws

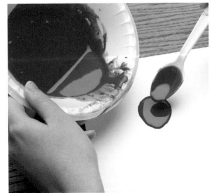

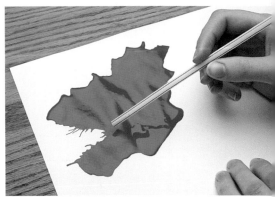

Instructions

1 Using water, thin each color of paint. With the spoon, drop the orange paint on the cardstock to form a small puddle (see photo above left).

2 Using a straw, blow on the puddle of paint (see photo above right). The force you use to blow creates the level of dramatic motion of the paint. Keep adding and keep blowing more drops of the orange paint as desired.

3 As you did in steps 1 and 2, repeat with the black paint—one drop at a time, blowing each one before going to the next—and then with the green.

TIP: You can combine this technique with splattering for even more interesting patterns.

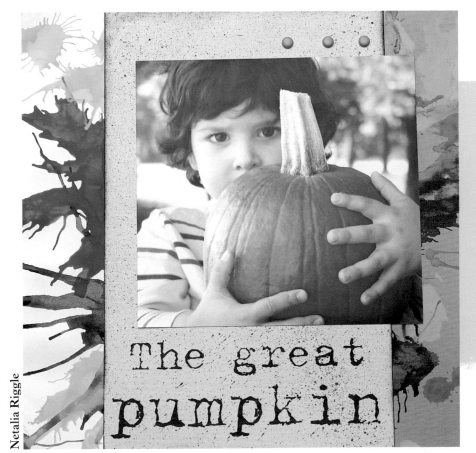

Netalia Riggle

The great pumpkin

Notice how the original page was painted on white cardstock. Designer Netalia Riggle unified the predominately green and orange color scheme with paper made using the same blowing technique on orange cardstock. This is a wonderful way to use painted papers to tie into the colors of the photograph.

String Art

Paint, plus any kind of string, yarn, fiber, twill tape, or even a shoelace, can be used to create this graphic and bold design. Have fun experimenting with all kinds of fiber—simply add paint and play to create endless possibilities. This is also a great technique to try on tags because their smaller size makes painting them very manageable.

Materials & Tools

Light pink, pink, and mauve acrylic paint

Foam plate or plastic lid

String, yarn, fiber, twill tape, or shoelace

Purple cardstock

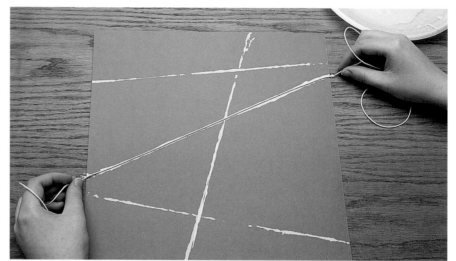

Instructions

1 Pour the light pink paint onto a foam plate or plastic lid to form a small pool. In order to prevent blobs of paint from sticking to the string as you work, thin the paint with water if it's too thick.

2 Cut a piece of string or fiber at least 3 to 4 inches (7.6 to 10.2 cm) longer than the size of the paper.

3 Hold on to both ends of the string or wrap the ends around your fingers like dental floss, then dip the string into the paint. If you're using a wide twill tape or shoelace, you may want to brush a thin coat of paint directly onto the surface of the fiber.

4 Using a quick up-and-down motion, apply the string to the cardstock in a random pattern or a radial design.

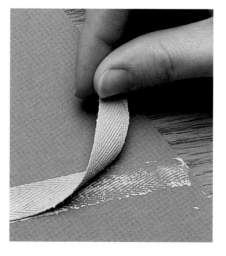

5 Repeat the technique using the pink and mauve paint, allowing one paint to dry before applying the other.

TIP: If you want to keep the fine details of a fiber's surface texture—for example, if you're using twill tape or a shoelace, as shown in the photo at left—use your finger to press gently on the back of the fiber as you lay it on the paper.

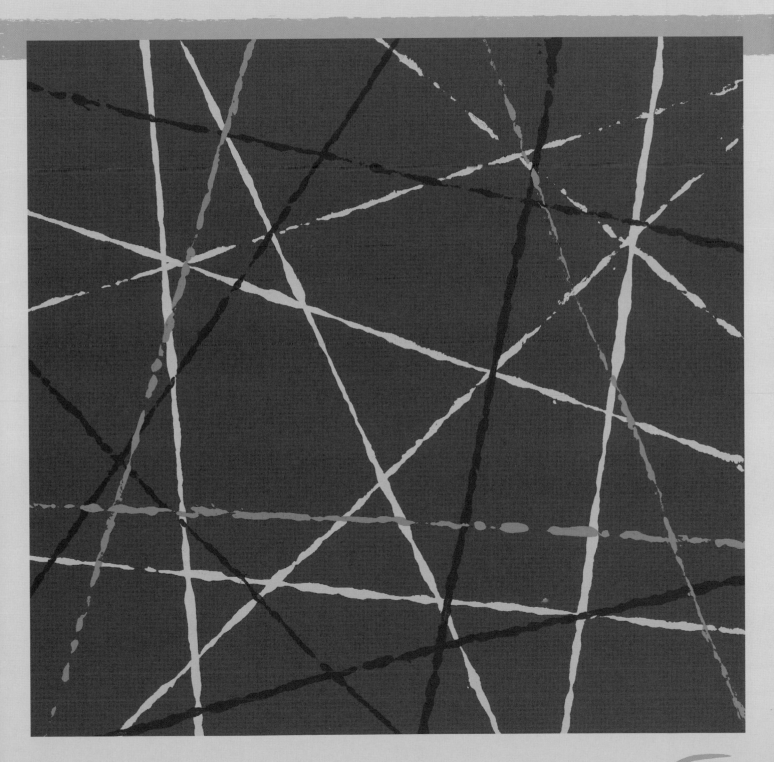

51

Marbles

I remember staring for hours at my Grandpa's large collection of marbles, which he kept stacked in glass jars along the basement stairs. And, while marbles are fascinating to look at, they're even more fun to paint with. Let's roll!

Materials & Tools

White cardstock

A box or a pan with sides*

Small plastic glasses or empty yogurt containers

Maroon, green, and blue gel paint

Marbles

Plastic spoons

A medium-size pizza box works great if you're creating a 12 x 12-inch (30.5 x 30.5 cm) background paper.

Instructions

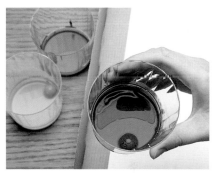

1 Place the cardstock in the box or pan. Put the paint in three small glasses or plastic containers with one color of paint in each.

2 Place a marble in each container. Swirl the containers to coat the marbles in paint.

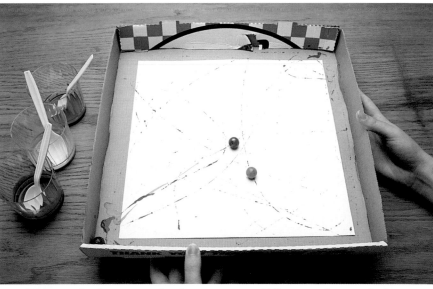

3 Using a plastic spoon, take the marbles from the containers and place them in the box or pan with the cardstock. Tip the box or pan back and forth in a rocking motion to roll the marbles around the cardstock.

4 When you have a design you like, use the spoon to remove the marbles from the box or pan. Wash the marbles before making another sheet.

Just Brush It

Strokes ✓

Plaids ✓

Salt ✓

Washes ✓

You can safely put away any anxious thoughts about needing to know fine brushwork. Instead, you'll learn how easy it is to use brushes, paint, and a few simple ingredients to create some amazing pages full of color and pizzazz.

The techniques in this chapter fall into two categories: those that show you how to load the brush with paint and work it on the paper, and those that use simple ingredients—water, salt, and gel medium—to enhance your brush strokes.

Brushwork

You don't have to be an accomplished decorative painter to make painted scrapbook pages. Each project in this section will tell you how to load and hold the brush. If you want to feel more comfortable with a technique before you begin a page, it's always a good idea to practice your strokes on a piece of scrap paper.

Dry-Brush

Anyone can look like a painter once they have learned to drybrush. This technique is easy to learn and can transform any solid-color cardstock into a visually rich work of art in minutes. This is one project where an older and more dilapidated paintbrush will give you better results. If you have several brushes that fit this description, experiment with them. You'll find that the characteristics of each brush will give different effects to the texture of the final brush strokes.

Materials & Tools

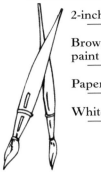

2-inch (5 cm) flat paintbrush

Brown and black acrylic paint

Paper towels

White cardstock

Instructions

1 Load the brush with brown paint. Empty most of the paint from the bristles by tapping the brush onto a paper towel. Keep in mind that the secret to this technique is found in the word *dry*. The brush should have very little paint left in the bristles before you begin to paint.

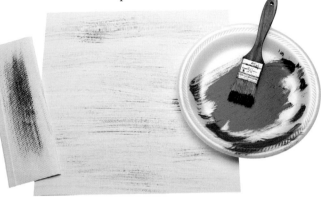

2 Apply the brown paint with fast, brisk strokes over the entire page, allowing some of the background paper to show. The goal is to enhance the background paper with flecks and streaks of color, not to completely cover it up.

3 Clean the brush and remove as much water as possible from the bristles.

4 Load the brush with black paint, and as you did in step 1, tap any excess paint onto a paper towel before lightly applying the black paint in quick strokes.

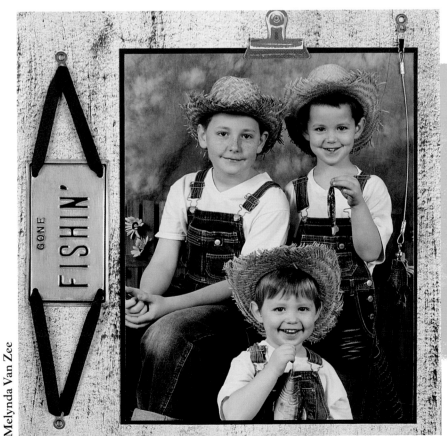

Melynda Van Zee

Simple drybrushing is a quick way to add texture to your background paper. The colors used for this page evoke weathered wood and pick up the feel of the fence in the photo. To balance the layout and continue the vertical orientation, I placed the license plate and ribbon toward the edge of the page.

Square Box Variation

If you have a visual that needs to take center stage, this drybrush variation will give it dramatic focus. Begin in the center of the paper and paint a very tiny square using four quick strokes. Continue adding strokes to the outside of the square to expand the design to the edges of the cardstock.

IT'S ACCEPTABLE TO TIP

If you want the edges of your paper to stand out, you might want to try painting them. It's a technique I call tipping. Hold the paper up as you lightly tap its sides with the brush. Some paint will naturally peek over the edge to the front of the paper. It may seem simple, but tipping gives the edges a nice definition. You can use this technique on background papers, frames, transparencies, and tags.

Blended Stroke

Two colors of paint and one paintbrush are all you need to make this dynamic hand-painted striped paper. Once you properly load the brush, the beautiful blending will happen naturally as you pull the brush down the page.

Peach and hot pink acrylic paint

Foam plate or plastic lid

1½-inch (4 cm) flat paintbrush

Cardstock

Instructions

1 Squeeze a pool each of peach and hot pink paint next to each other on a foam plate or plastic lid.

2 First, load the brush with peach paint. Then dip one corner of the brush into the pool of hot pink paint. The brush is properly loaded when one edge of the brush is pink and the other edge is orange.

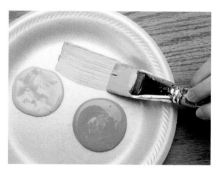

3 Take a practice stroke on your paint palette or piece of scrap paper. The two colors should blend in the middle.

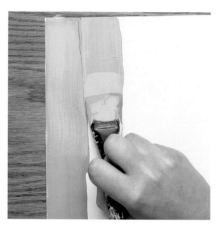

4 Beginning on the right side of the cardstock, place the brush parallel with the top edge of the paper. Hold the brush so the edge with pink paint is to the right. Using one long, steady stroke, pull the brush to the bottom edge of the cardstock.

5 It's not necessary to clean the brush after each stroke; simply load the entire brush with peach paint and dip the corner into the hot pink paint as you did in step 1.

6 Before beginning the second stroke—and for all consecutive strokes—place the brush at the top of the page to slightly overlap the last stroke. Always hold the brush so the edge loaded with pink paint stays to the right.

7 If the colors don't blend to your liking after completing a stroke, carefully re-stroke the stripe once for a more blended look.

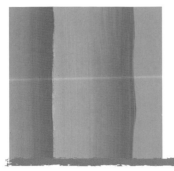

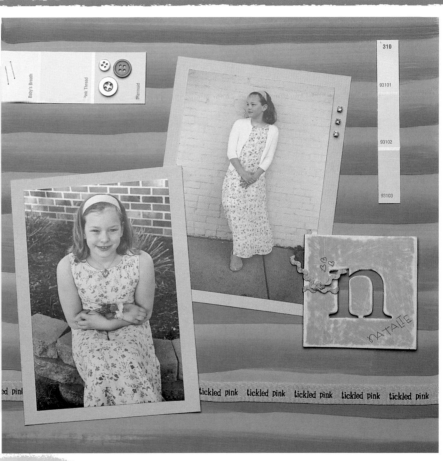

*W*hile you can use any color combination for the blended strokes, designer Brenda Huisman drew from the pink and orange scheme to build her page. The paint chips and buttons as design elements pick up the background color as well as that of the flowers on Natalie's dress. As you can see, repeating colors around the page moves the eye from place to place on the layout.

Brenda Huisman

Gradated Color

Quick brush strokes are all that are needed to create this vibrantly colored background page. When applying the hot pink paint, your goal is to make the color more intense at the bottom and top edges of the paper while gradually lightening the color as it approaches the middle of the page. Using acrylic paint thinned with water will help the paint glide smoothly across the page and make the colors more transparent.

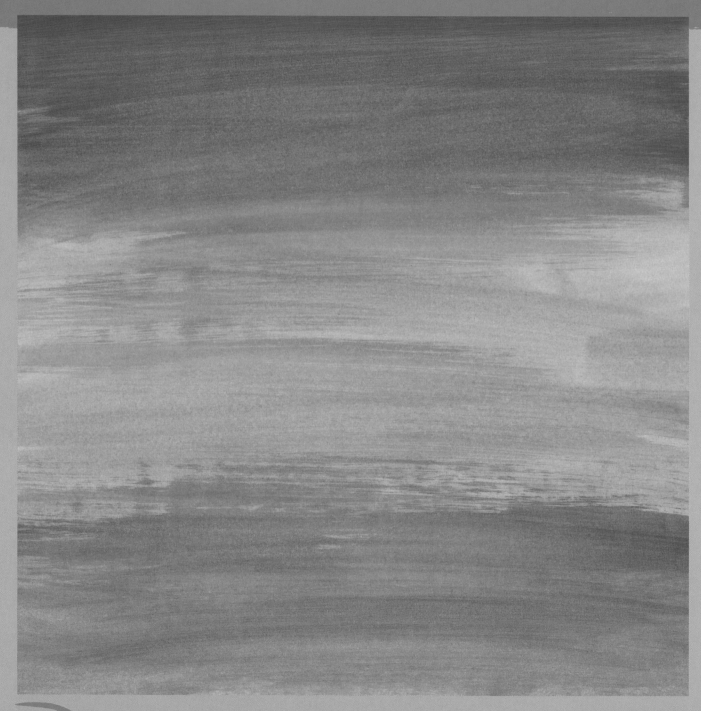

Materials & Tools

1-inch (2.5 cm) paintbrush

Paper towels

Pink and yellow acrylic paint

White cardstock

Instructions

1 Wet the brush, then tap it on a paper towel to remove any excess water. Load the brush with pink acrylic paint that has been thinned with water.

2 Thinking of the cardstock as divided in thirds, stroke the pink paint quickly across the top third and bottom third of the page. The color should be more intense toward the bottom and top edges of the cardstock.

3 After cleaning the brush, load it with thinned yellow paint.

4 With the yellow paint, use quick brush strokes to paint the middle third of the page. As the brush empties of paint, gradually overlap the pink by brushing slightly into the pink sections to blend the colors.

There's more than one way to use a painted paper. When I made this design, I used horizontal strokes, allowing the graded colors to call to mind a peaceful sunset. Notice how the designer turned the page 90 degrees to make the lines run vertically. This gives an upbeat, funky feel to the design that she reinforced with bright ribbons and a bold flower accent.

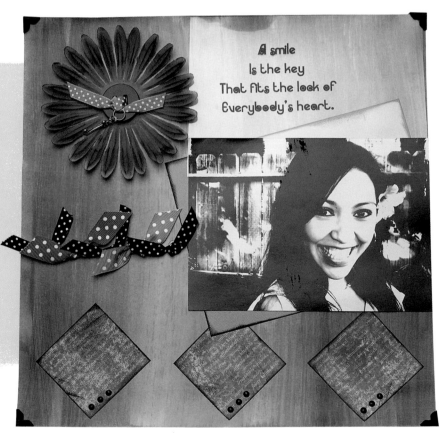

A smile
Is the key
That fits the lock of
Everybody's heart.

Maranatha Baca

63

Painting Plaids

Even though painting a plaid seems complicated, selecting the right paintbrush makes this project much easier than it looks. You can buy paintbrushes with divided bristles, that are made especially for painting two- or three-line stripes with one simple stroke of the brush. Not only can you use them for making plaid papers, you can use them to make striped papers that coordinate with your plaids. Keep in mind that the secret to success to painting plaid is to take the time to allow each color to dry before applying the next one.

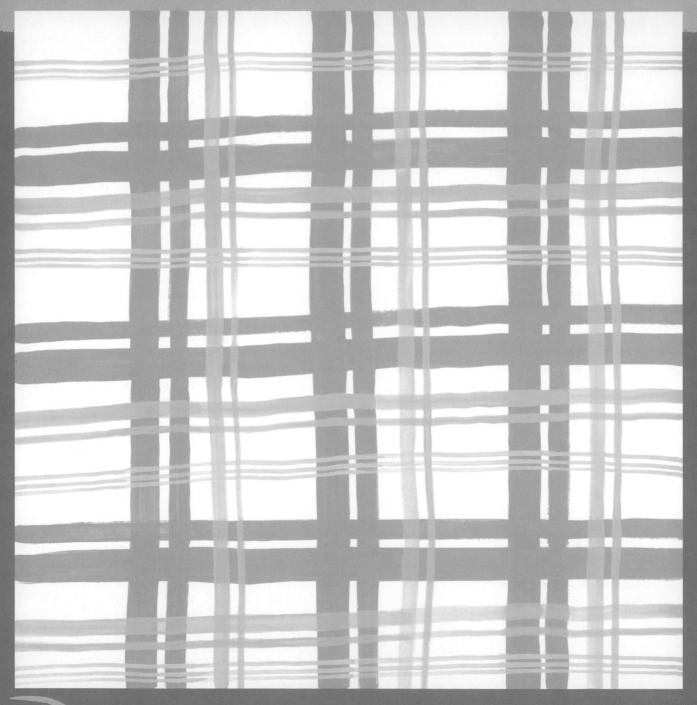

Materials & Tools

Purple, mint green, and pink acrylic paint

Double- and triple-stroke liner brushes

White cardstock

Instructions

1 Using the purple paint, load the double-stroke brush the same way you would load any flat brush. Stroke left to right on the cardstock in one fluid motion to create the first double stripe. Continue to reload the brush as necessary. Paint two more sets of double stripes on the cardstock, leaving an equal distance between each set.

2 After completing the series of double stripes, turn the cardstock and paint three more sets of purple stripes perpendicular to the first set of stripes. Allow the purple paint to dry before proceeding to the next color.

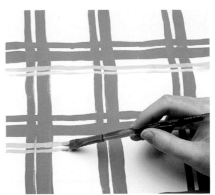

3 Load the double-stroke brush with mint green paint and stroke left to right directly below each set of purple stripes. Turn the cardstock and repeat. Allow the paint to dry.

4 Load the triple-stroke brush with pink paint. Paint four sets of pink stripes perpendicular to the green stripes.

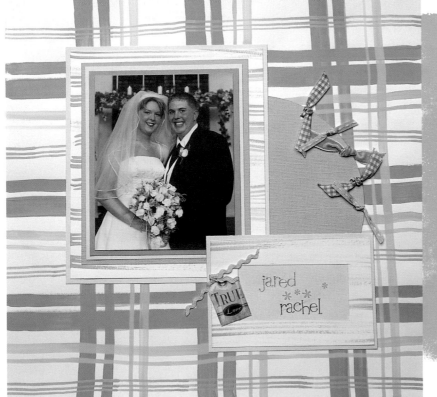

Brenda Huisman

The colors you use for painting your plaid provide a harmonious choice of colors to use for your accents. One way to repeat a favorite color from the background is using it for your photo mats and title blocks. In this layout, the designer chose to mat the photo with five different layers of color—picking up all the colors of the painted plaid. The pink striped layer was made by using the triple-stroke brush on white cardstock.

65

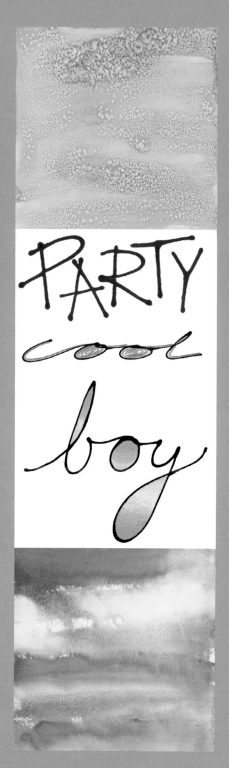

Paint Plus

By adding simple ingredients to your paint, you can enhance the effects of your brush strokes. We all know that you need to mix watercolor with water before applying it to the page, but what happens when you apply it to wet paper? And what about salt when the crystals meet paint? The magic is unmistakable. Finally, gel or opaque paint straight from a thin-tipped bottle will take your lettering to new dimensions.

Salt

It may be dangerous to tell you how to do this. Once you see the results, all your background papers from this point on just might feature this technique—and no two papers will ever be alike. When you apply salt to still-wet watercolor backgrounds, the salt soaks up the water and paint to leave a wonderful speckled surface. You can actually watch the design bloom before your eyes. Ready to live dangerously?

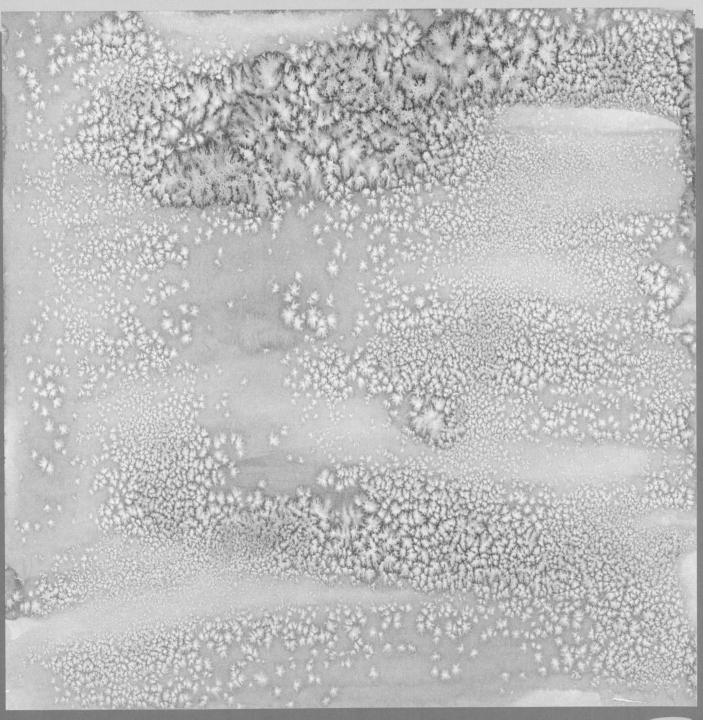

Materials & Tools

2-inch (5 cm) flat brush

Cream cardstock

Green watercolor paint

Table salt

Instructions

1 Using the brush, apply a thin coat of water to the surface of the cardstock.

2 Dip the brush in water before loading it with the green watercolor. Paint a solid background of green on the cardstock.

3 While the color is still wet, sprinkle a handful of table salt on the page.

4 When the paint is dry, use your hand to gently brush the salt off the page.

Rock Salt Variation

This variation of the salt technique creates a paper that would be great for any snow- or winter-themed page. Just follow the same steps as above using blue for the background color and rock salt instead of table salt. The larger crystals will soak up even more paint to create a soft, beautiful snow-like paper. The photos below capture the transformation.

As I watched the crystals of the rock salt transform the blue paint, I was reminded of a clear blue sky after a big snow-storm. With photos on hand of three active boys playing in the snow, my page was practically done! This layout is also an example of another way to use stencils. Notice how I dry brushed the paper stencils with paint, and how I applied just a bit of paint to the edges of the acetate stencil letters. And, I just couldn't pass up using the large S as a photo frame.

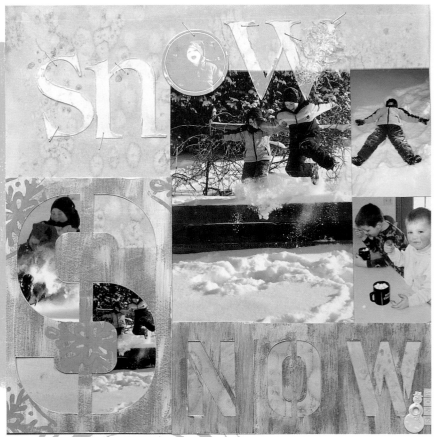

Melynda Van Zee

Watercolor Wash

With watercolor, the magic is the mystery—you never know exactly what the finished piece will look like—and that's the best part. Watercolor has a life of its own and moves at will. Let this happen. You'll create much more interesting background papers if you allow the paint to have a part in the production.

Since this is a *wet-on-wet* painting technique, you'll be applying wet paint to wet paper. You don't want to soak the paper with water—a light coating is all you need. Don't overwork the watercolor. Instead, allow the paint to interact with the water on the paper.

Materials & Tools

12 x 12-inch (30.5 x 30.5 cm) piece of watercolor paper or sheet of heavyweight cardstock

Large round brush

Orange, pink, and yellow watercolor paint

Instructions

1 Prepare the paper by brushing a thin coat of water over the entire sheet.

2 Wet a large brush with water before loading it with the orange paint. If you don't have watercolors, add water to acrylic paint and use this just as you would a watercolor.

3 Move the brush in a sweeping stroke across the bottom of the page. Don't paint over this stroke; instead watch as the paint mixes with the water already on

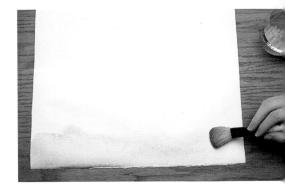

the page. Allow the paint to flow where it wishes.

4 Clean the brush and add strokes of the pink and yellow watercolors. Keep the brush very wet. Allow the paint to flow at will. It will mix and blend as you continue adding color.

Wash Variation

This variation produces some interesting swirls and shapes in the middle of the paper. Prepare the paper by brushing a light coat of water over the paper's surface. Spritz a dry cake of sparkling watercolor paint with water. Allow time for the water to soak into the paint to soften it. Swirl a wet paintbrush in the paint. Stroke the brush filled with the shimmering paint along the top and bottom edges of the paper. Grasp the edges and curve them upward to make the paint flow to the center of the page. Let the paint pool in the center for a few seconds, then lay the paper flat, allowing the paint to go where it will.

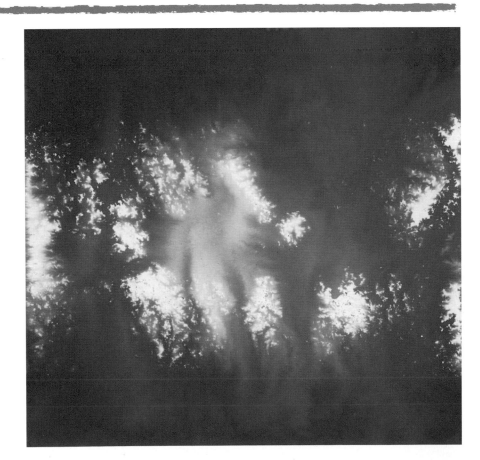

PARTY

cool

boy

Lettering with Paint

While markers or gel pens are most often the tools of choice for adding lettering to a page, this project challenges you to pick up a paintbrush or squeeze bottle. For this project, I created three different titles on separate pieces of cardstock. You can see how I used the Cool title in the layout below. You can easily enlarge these designs to cover a background paper, or use words multiple times on the paper to create an interesting design. Even though I used gel paint in squeeze bottles, I encourage you to experiment making titles using a brush or opaque paint in squeeze bottles—the results will always lend your unique signature to any page.

Materials & Tools

- Bottles of gel paint
- White cardstock
- Colored pencils

Instructions

Party

Need you say more? For a fun, bold, uppercase title, use the tip on a squeeze bottle of red gel paint to print the word on the white cardstock. Allow the paint to dry.

Cool

What's cooler than a cool-blue pool? Use the tip on a squeeze bottle of blue gel paint to write the stretched out word in cursive. With a blue watercolor pencil, add swirls in the middle of the Os.

Boy

One word can say so much about all the men in your life. Use the tip on a squeeze bottle of black gel paint to write the word in lowercase cursive. Use lime-green and blue watercolor pencils to fill in the spaces, overlapping the colors as shown in the photo. Use a water-filled blending pen to blend the colors as desired.

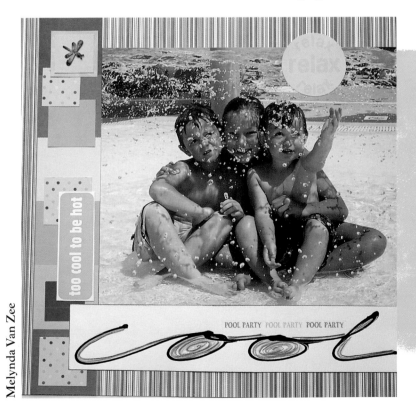

Melynda Van Zee

too cool to be hot

POOL PARTY POOL PARTY POOL PARTY

A custom-lettered title can capture the moment almost as well as the photo. Since I didn't want the photo to look as if it were floating off the page, I placed it close to the right side of the paper with the title lined up underneath as a visual anchor. By moving the title up from the bottom of the page, I allowed the colorful printed paper to draw your eye right to it.

Paint à la Faux

Artists have used faux finishes for centuries to create beautiful textures on walls and furniture. What is a faux finish? The word faux comes from a French word that means false. When you faux finish, you fool the eye by using paint to simulate the look of other more expensive materials or surfaces. The best part of using these techniques for making painted scrapbook pages is that you will be working with one piece of paper at a time instead of figuring out how to cover a whole wall.

Sponging ✓

Marbling ✓

Combing ✓

Crackle ✓

Masking ✓

Faux Tools

In order to get some of the great faux effects, you'll be using tools other than brushes for painting. You can buy faux-finish tools at craft and home-improvement stores, but most of the following techniques use items you can find around the house.

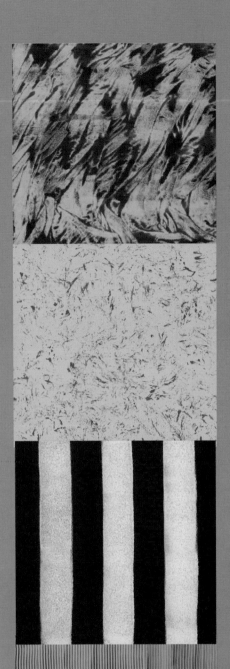

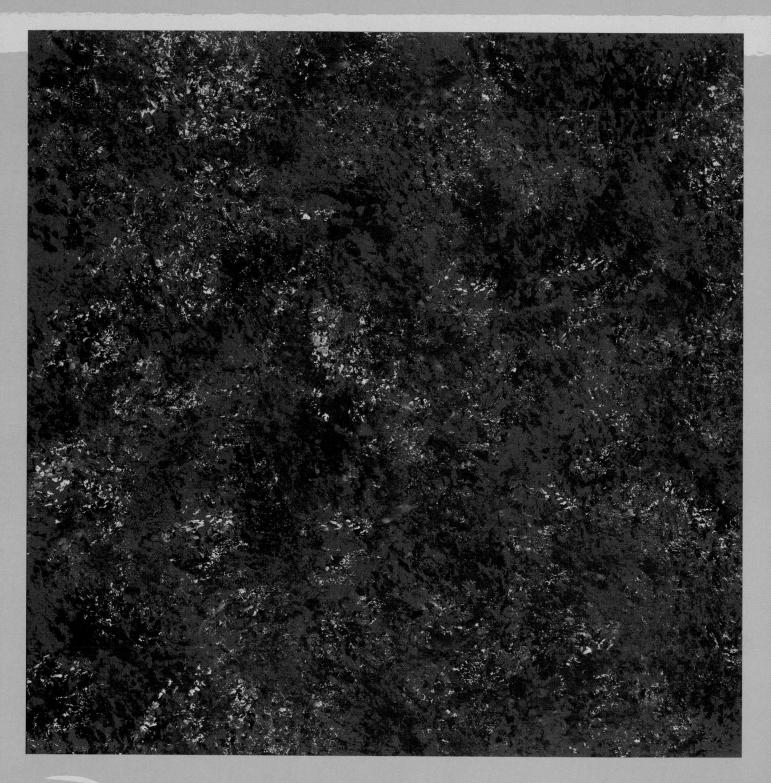

Sponging

A soft touch, a bit of paint, and a natural sponge are all you need if you want to add beautiful depth to your painted pages. The finished look will depend heavily on your color combinations, and you'll find the effect becomes more stunning as you apply additional layers of paint.

For a soft and blended look, I recommend selecting a light, medium, and dark shade of the same color. This will result in a beautiful tone-on-tone paper. You can achieve a dramatic look by using contrasting colors, such as the dark brown, deep red, and cream colors used for this painted page. The final touch of cream adds the perfect highlight—just like adding a beautiful piece of jewelry to your favorite outfit.

Materials & Tools

Brown cardstock

Dark brown, red, and cream acrylic paint

Foam plate or plastic lid

Small natural sponge

Newspaper or paper towels

Instructions

1 Squeeze each color of paint onto a foam plate or plastic lid to form three separate puddles.

2 Wet a small natural sponge with water, then squeeze out all the excess.

3 Lightly dab the sponge in the brown paint. To prevent paint from sticking in the holes of the sponge, blot the sponge on newspaper or paper towels to remove all excess paint.

4 Pounce the loaded sponge over the entire page (even off the edges) by tapping the sponge straight up and down. Be careful not to drag the sponge as it touches the paper or the paint will smear. Randomly fill the space (approximately 60 percent of the page), leaving some areas of your background paper showing through.

5 Rinse your sponge thoroughly with water, then wring out all excess water.

6 Tap the sponge in the red paint. Remove any excess paint by blotting the sponge on a paper towel. As you did in step 4, pounce the sponge gently over the page, overlapping some of the first color and filling in some of the empty areas with color. Cover approximately 40 percent of the page with this color. Rinse the sponge thoroughly, then wring out all excess water.

7 For the final highlight, add cream paint to the design by lightly tapping the sponge randomly over the design. Don't overdo it—a little dab here and there is all you need.

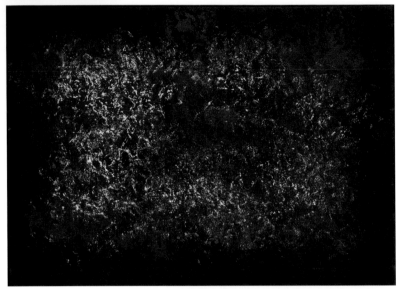

TIP: When sponge painting, you want to avoid the halo effect, which is one of the easiest mistakes to make when using this technique. As shown in the photo at left, you can clearly see the halo made by not sponging all the way to the edges. To prevent this from happening, cover your work surface before painting, then don't be afraid to sponge away!

*T*he rich brown color scheme of this sponged paper is repeated in the layout by the mats, ribbon, and even the leaves in the photo. Notice how the printed papers have been lightly sponged to tone them down and make them blend better with the background. Designer Tanya Mundt also created visual interest in her title by stamping all her painted letters horizontally, except for the M.

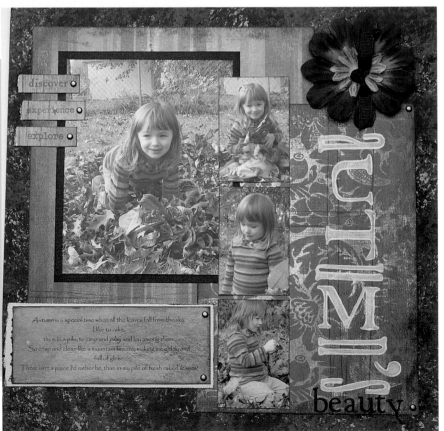

Tanya Mundt

78

Sponging Variations

There are many more great textures you can create with sponge painting. All you do is change the colors or type of sponging tool, then follow the instructions for Sponging on page 77.

Tone-on-Tone

As shown in the photo right, this effect was created using a natural sponge and a light, medium, and dark shade of one color. To get this soft and muted look, sponge on the medium shade first, then the dark, and last, a bit of the lightest shade.

Bath Pouf and Plastic Bags

Try painting a background by applying paint with a mesh bath pouf (photo, far left), an old rag, or a plastic bag balled up in your hand (photo, near left). A word to the wise...be careful when using a plastic grocery bag with lettering on the side. Tuck the lettering into the middle of your hand, or you may find unintended colors added to your project. (Don't ask me how I know that!)

Dish Scrubber

Use a dish scrubber (the kind with a soap reservoir in the handle) for a fun sponging tool. I like this tool because it keeps your hands clean and is easy to control. To make the moon, trace around the curved edges of a large plastic lid, moving the lid as needed to get the crescent shape (see photo top right). To paint the moon, pounce the scrubber first in the yellow, then apply it to the page, allowing it to dry before doing the same with the orange paint (see photo bottom right). After the moon dries, use purple, then periwinkle to paint the sky. You can tap or swirl the scrubber as you paint to create interesting patterns. Just remember to keep the pattern random by changing the angle at which you hold the tool.

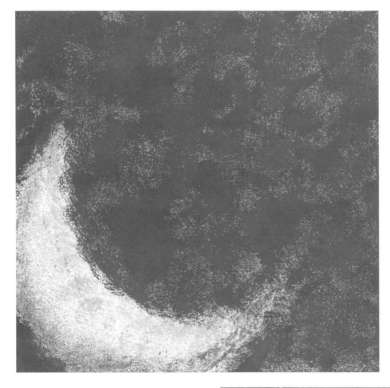

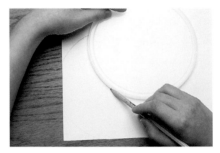

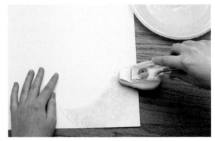

It's hard to believe that the rough surface of a dish scrubber can create such a pretty paper. Once the paper was painted, I wanted to capture the same feel in my journaling. I decided to use colored pencils because they produce a nice soft line. The delicacy of the patterned vellum complements the layout, and by folding its edge over, I allowed more of the painted background to peek through.

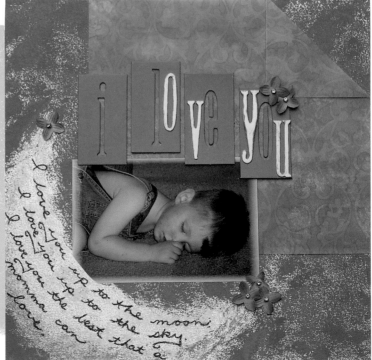

Melynda Van Zee

80

Kitchen Sponge

The humble kitchen sponge—the kind you can purchase in any grocery store—is a great way to create the effects of tiles or bricks as shown in the photo. The subtle coloring was created by applying maroon paint to brown cardstock. You'll find that many different sizes of sponges are available and that they'll all create different looks. Block sponges can also be used to add shapes to your pages—they make great frames for photos. Or, think about using a sponge to create a personalized color-blocked design by using a combination of different colors.

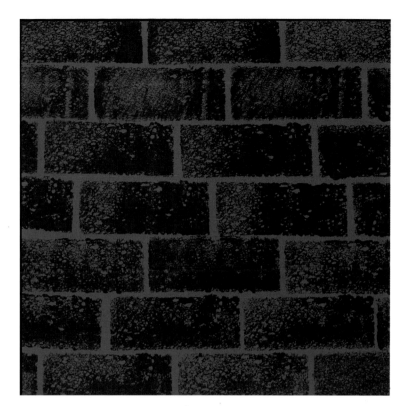

Melynda Van Zee

Inspiration can go both ways. Sometimes the painted paper will inspire a layout. At other times, a texture in a photo can inspire you to make just the right paper. Once I saw the wonderful brick pattern in the photo, I knew it was time to get out the kitchen sponge.

Rag Rolling

If you can think backwards, you can rag roll! In this technique it's not about what you put on the page but what you take off, since the lush, fabric-like look is created by removing paint with a rag. Adding a flow medium or extender to your brown paint will give you a longer working time before the paint dries—but you still want to work fast and not stop midway to grab a snack once you start rolling.

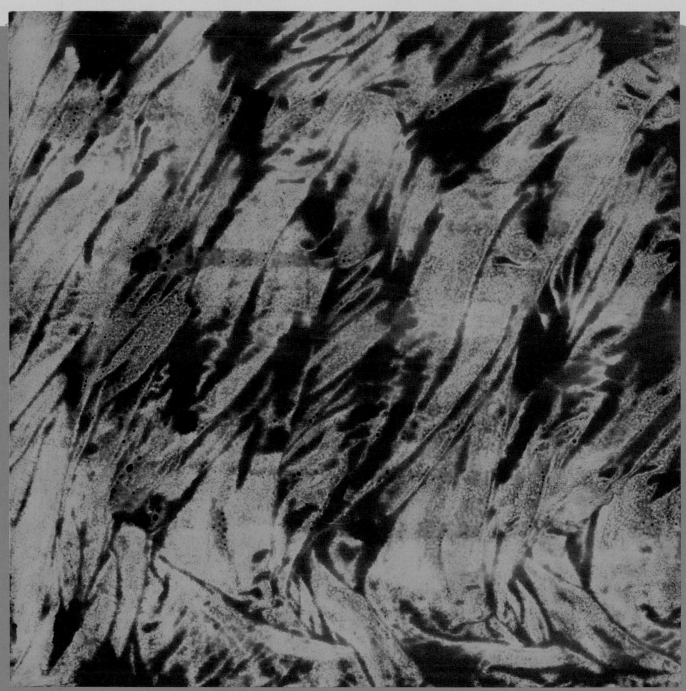

Materials & Tools

Turquoise and brown acrylic paint

Cardstock

2-inch (5 cm) flat paintbrush

Rags

Bucket of water

Instructions

1 Using the paintbrush, paint a solid coat of turquoise on the cardstock. Allow the paint to dry.

2 Paint a coat of brown paint entirely over the dried turquoise layer.*

3 Dampen a rag with water and wring out any excess, twisting the rag as if you are wringing out clothes.

4 Starting at the top, roll the twisted rag down the page. The rag will lift the paint off the page as you go (see photo top right). Keep rolling and removing paint. Rinse the rag in water as necessary. If the first rag becomes

completely saturated with paint, dip a new rag in water, wring it out, and continue rolling.

You may be wondering why it wouldn't be easier to skip this step by simply coating a sheet of turquoise cardstock with brown paint. If you did, you would find that the brown paint would be impossible to remove since it would have soaked into the unpainted cardstock. The turquoise base coat creates a slick, acrylic surface that allows you to successfully remove the second coat.

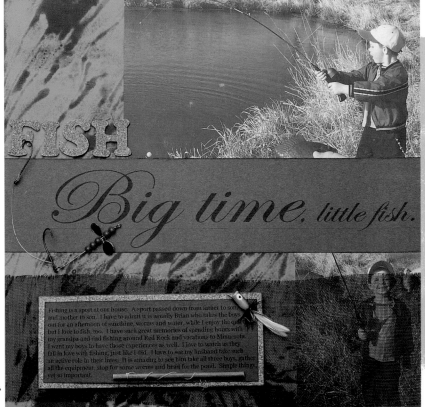

Melynda Van Zee

Painted pages can surprise you. Rag rolling the brown on turquoise gave me what I thought was a modern color combination. While working on the layout, I was surprised that I achieved a more timeless look by using rusty screen, sepia-toned photos, and actual fishing lures. In fact, here's a good exercise for stretching your creativity: Make two painted pages using the same technique and colors, then create two very different layouts from each.

Two-Step Marbling

With only a brush and sponge, you can achieve a beautiful marbled effect. The key to this technique is to work diagonally on your paper—start painting at one of the top corners and work toward the opposite bottom corner. The final step is to add a touch of sponged highlights to simulate marble grain.

Materials & Tools

Light olive-green cardstock

1-inch (2.5 cm) flat paint-brush

Light olive-green, dark olive-green, and metallic gold acrylic paint

Small natural sponge

Paper towels

Instructions

1 Dip the brush in the light olive-green paint. Hold the brush straight up and down, and, starting at the upper right corner of the paper, use a series of small brush strokes to create a wavy diagonal line. Skip some space on the cardstock and paint another diagonal line. Repeat randomly, moving in the same diagonal direction until you reach the lower left-hand corner.

2 With the dark olive-green paint, use the same brush strokes to fill in the spaces between the light olive-green lines. Slightly blend the colors where they meet.

3 Wet a small natural sponge and squeeze out all excess moisture. Dip the sponge in the dark-olive green paint. Remove all excess paint by tapping the sponge on a paper towel. Tap the sponge over the page. Clean the sponge.

4 Wet the sponge and squeeze out all excess moisture. Dip the sponge in the light olive-green paint. Remove all excess paint by tapping the sponge on a paper towel. Tap the sponge over the page. Clean the sponge.

5 Wet the sponge and squeeze out all excess moisture. Dip the sponge in the metallic gold paint, removing all excess paint by tapping the sponge on a paper towel. Lightly pounce the sponge over the entire page, remembering to paint in the same diagonal direction as before.

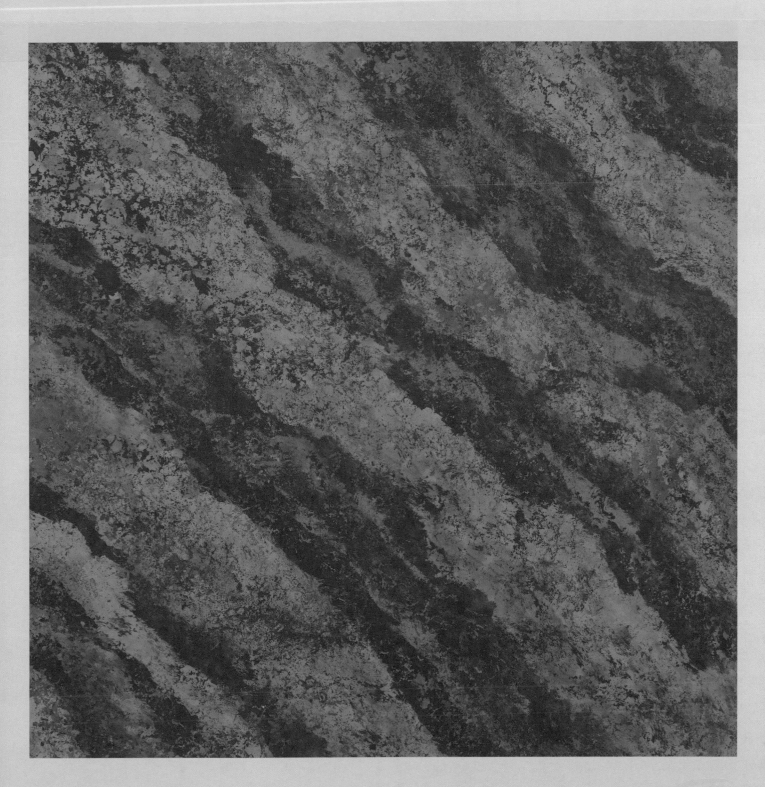

Feather Dusting

Did you ever think you'd love to dust? Feather dusting is one of my favorite painting techniques because I can create a dramatic effect with an inexpensive feather duster and a very small amount of paint. So turn on a little music and pounce away—dusting has never been as fast or so much fun!

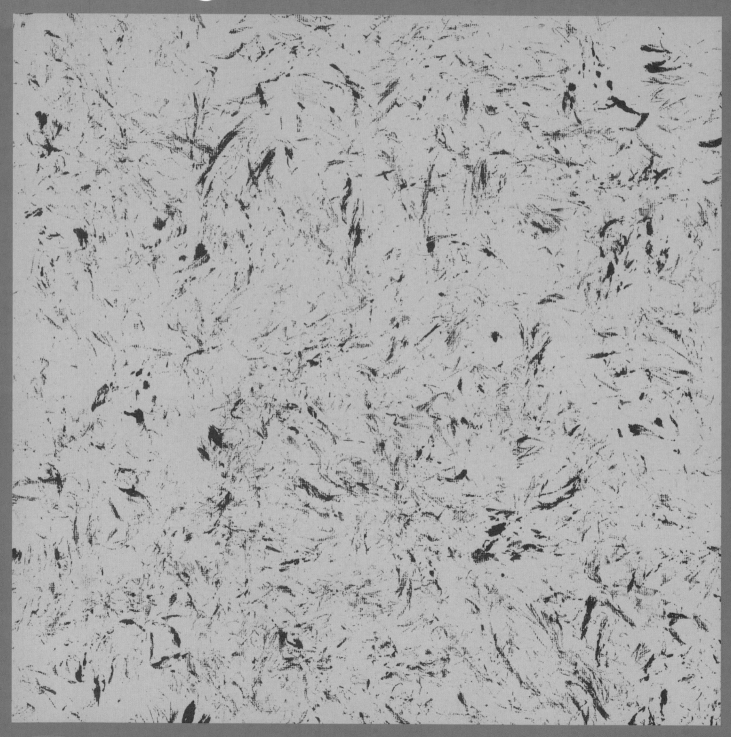

Materials & Tools

- Burnt orange acrylic paint
- Large paint tray or plastic lid
- Natural feather duster
- Paper towels
- Olive-green cardstock

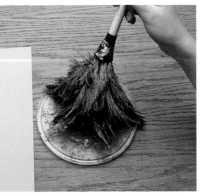

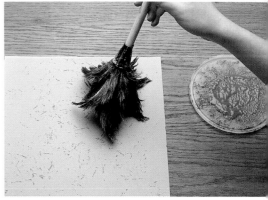

Instructions

1 Pour the paint onto a large paint tray or plastic lid.

2 Distribute the paint on the feathers by pouncing the duster up and down in the paint a few times. Remove any extra paint by tapping the feather duster on a paper towel.

3 Place the cardstock on a flat surface. While holding the feather duster straight up and down, lightly touch the paper.

Then rotate the feather duster in your hand to turn the feathers before touching the paper again. Tap the paint on the top of the page, touch the bottom, and then tap the sides. Remember to let some of the strokes go off the edge of the page. Five or six taps of the duster is all it should take to cover the entire surface—it's that fast!

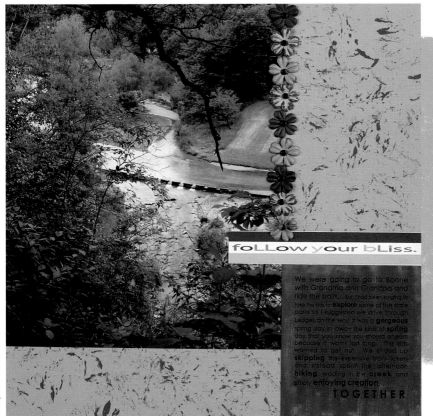

foLLow your bLiss.

We were going to go to Boone with Grandma and Grandpa and ride the train,… but I had been longing to take the kids to **explore** some of the state parks so I suggested we drive through Ledges on the way. It was a **gorgeous** spring day in Iowa: the kind of **spring** day that you know you should cherish because it won't last long. The kids wanted to get out. We ended up **skipping** the expensive train tickets and instead spent the afternoon **hiking**, wading in the **creek** and simply **enjoying creation**.

TOGETHER

Melynda Van Zee

I love the light and airy painted papers you can achieve with this technique. In this case, the feeling I got when looking at the paper made me choose a photo for the layout that captures the freshness of spring. To help give the page a cohesive look, I added touches of the background paint to the paper flowers and dry brushed the edges of the journaling block.

Painting Stripes

One lesson I've learned from all the walls I've painted in my own home is that you can cover a large amount of wall in a short amount of time when using a good paint roller. Actually, in all honesty, my husband is usually the one running the roller, and he always seems to finish a huge section of wall while I'm still stuck high on a stepladder with a half-finished trim job. The same principle holds true when painting scrapbook paper. Three quick swipes of a small paint roller are all it takes to create this rich, bold-striped scrapbook paper. And, the best part—no masking tape required.

Materials & Tools

- Small craft paint roller
- Cream acrylic paint
- Maroon cardstock

Instructions

1 Load the paint roller with cream paint. Test to make sure you have enough paint on the roller by rolling it across a piece of scrap paper. When the roller is properly loaded with paint, begin at the bottom of the maroon cardstock and roll to the top in one fluid stroke.

2 Reload the paint roller and repeat the stroke two more times, evenly spacing the stripes on the paper.

3 Touch up any small areas by rolling the entire stripe again, starting at the bottom and working toward the top.

Look closer. The fence rails in the photo subtly echo the painted beige stripes on the page. And the beautiful apples pick up the deep red stripes of the cardstock. But the real magic of this layout happens because designer Nicole Spinney has selected the right shades of green to add to the page—as complementary colors, red and green make a bold statement when effectively paired together.

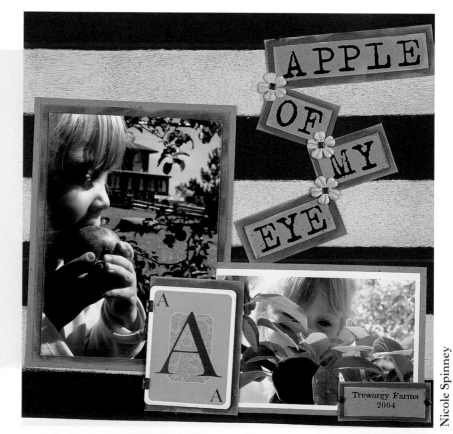

88

Combing

Can you hold a credit card? Hmmm—thought so. If you can swipe a credit card through a machine, you have basically mastered the art of combing. This is a paint-removal technique like Rag Rolling (page 82). You drag the comb through wet paint to make stripes or corduroy-like textures—and the combinations are endless.

You can make a comb by cutting notches in one of the long sides of an old credit card. Or, you can buy combs specially made for faux finishing. Since you want the paint to be wet when you drag the comb through it, paint and drag in sections as you work the page.

Materials & Tools

1-inch (2.5 cm) flat paint-brush

Blue acrylic gel paint

Blue cardstock

Combing tool or credit card cut with notches

Scissors

Instructions

1 Using the brush and blue acrylic gel paint, paint a lengthwise strip on the cardstock that covers approximately one-quarter of the page.

2 Drag the combing tool down the page from top to bottom. Use a paper towel to wipe paint from the edges of the tool before starting again. Place the combing tool beside the first stroke, and pull

the tool down the page parallel to the first stroke.

3 Continue painting and combing in sections until the entire page is complete.

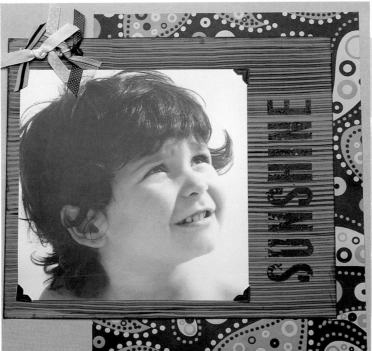

Netalia Riggle

The lined paper you get from the combing technique is versatile and fun. Here the designer cut the paper to make an oversized mat, giving her plenty of room for placement of the photo and the title. This is a page layout you could use over and over again with any of the painted papers in the book.

Checkerboard Variation

Use olive-green gel paint and a sheet of green cardstock to make this tone-on-tone checkerboard design. Paint the page in sections as you did for Combing on page 91. However, instead of dragging the comb from top to bottom, keep changing the direction of the combed stroke to create the checkerboard pattern.

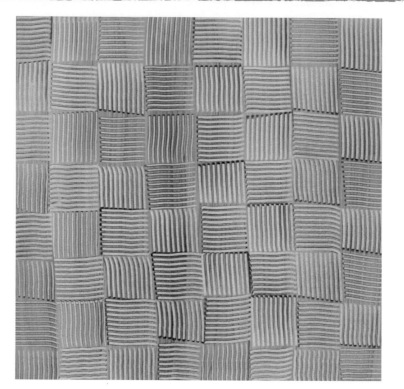

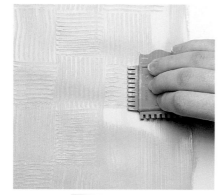

Burlap Variation

To make this burlap-look background paper, start with cranberry gel paint and a lavender sheet of cardstock. As you did for Combing, paint the page and work in sections. Each painted section will be combed twice. First, stroke across horizontally as you work down the page, then, on the same section, stroke vertically top to bottom.

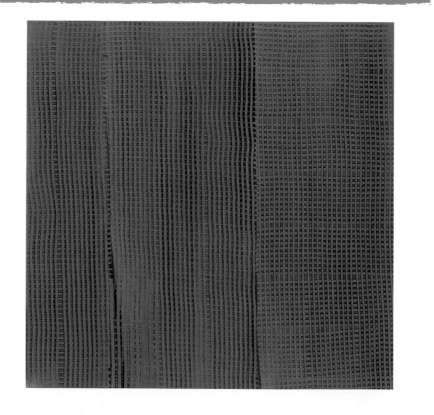

Crackle

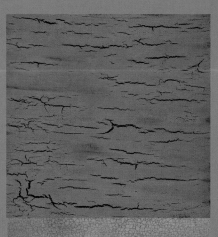

Crackle brings an unexpected life of its own to every project because you never know exactly how it's going to turn out. The finished look depends on the crackle medium you use, how you apply it, and the magic that transpires in between.

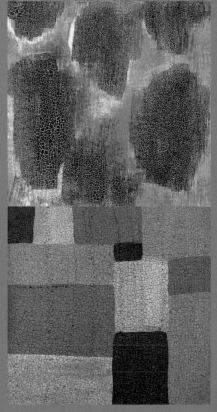

One-Step Crackle

By applying one coat of crackle medium, and then painting over it, you can create this dramatic, bold paper. The amount of crackle medium you use determines the size of the cracks. A thick coating will result in large cracks, while a thin coating will create tiny cracks.

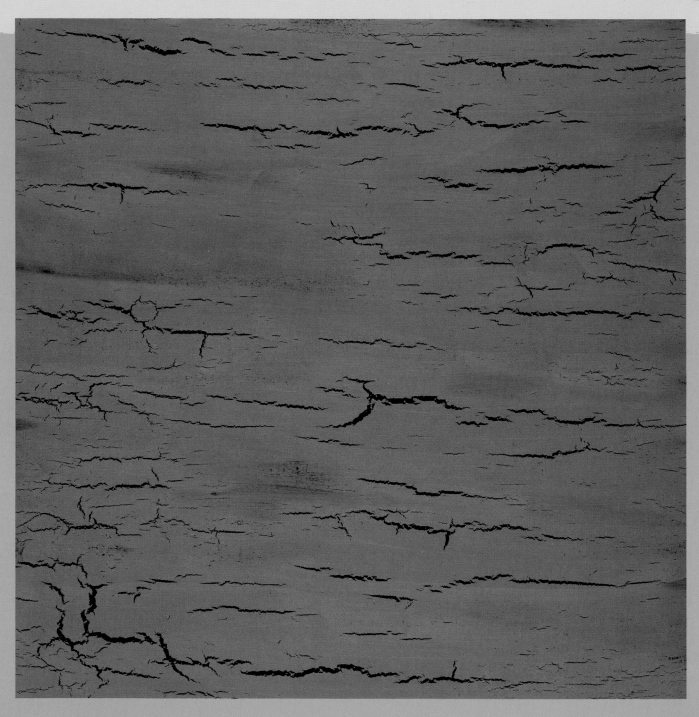

Materials & Tools

- Foam brush
- Crackle medium
- Black cardstock
- 2-inch (5 cm) trim brush
- Metallic gold acrylic paint
- Spray acrylic sealer

Instructions

1 Using the foam brush, apply a thick coat of crackle medium over the entire surface of the black cardstock. Brush in one direction using big sweeping strokes. If you want larger cracks, apply a thick coat of the medium. For tiny cracks, apply a thin coat.

2 When the crackle coat is dry to the touch, use the trim brush to paint a coat of metallic gold paint over the entire page. Paint in one direction, and paint only once. Do not add to or go back over the paint when it's drying. As the metallic gold paint dries, it will begin to crackle.

3 Allow the paint to dry, then seal the paper with a coat of clear acrylic spray.

This sunset seems to sparkle even more when offset by the metallic gold of the painted crackle paper. Notice how the photo dominates the top two-thirds of the layout. Much like the magic of threes mentioned on page 33, it's pleasing to the eye to look at a composition that divides a visual plane in thirds. The striped ribbon and oval medallion finish this simple but elegant page.

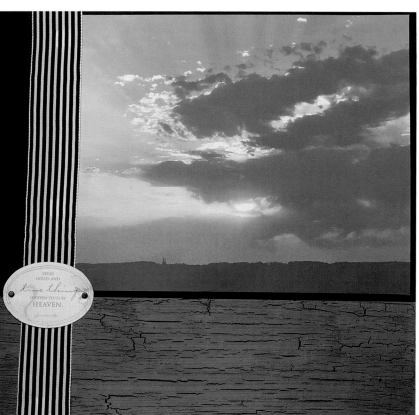

Melynda Van Zee

Porcelain China Crackle

This two-step crackle medium creates the look of an old porcelain china cup, delicate and beautiful. For a solid-color crackle effect, paint the background in one color of your choice, then apply step 1 and step 2 of your purchased china-crackle product—you'll see tiny crystal-clear cracks appear over the entire surface. You achieve the aged look by applying an antiquing gel as the finishing touch. To protect your crackle finish, you can spray the finished page with an acrylic sealer.

- Cardstock

- Sage green acrylic paint

- China crackle medium

- Paintbrush

- Antiquing gel or brown acrylic paint

- Soft cloth

- Spray acrylic sealer

Instructions

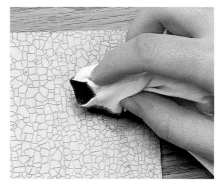

1 Using the sage green paint, paint a solid background of color on the cardstock.

2 Use a brush to apply step 1 of the china crackle medium. Allow step 1 to dry to a clear finish before applying step 2. If you want small cracks, apply both steps lightly. For large cracks, apply a thick coat of each step.

3 Using a soft cloth, rub antiquing gel or brown paint over the dry crackle coat, making sure to rub the gel into the cracks. Wipe away any excess.

4 After the antiquing gel or paint is dry, spray the page with acrylic sealer.

The fine cracks made by using a porcelain china crackle provide just enough background texture when designing a page with a photo collage. Since you want the multiple images to be the focal point, you want a background that is inviting and interesting without being overwhelming. I made the frame from cardstock, then inked the edges of it to coordinate with the crackle lines.

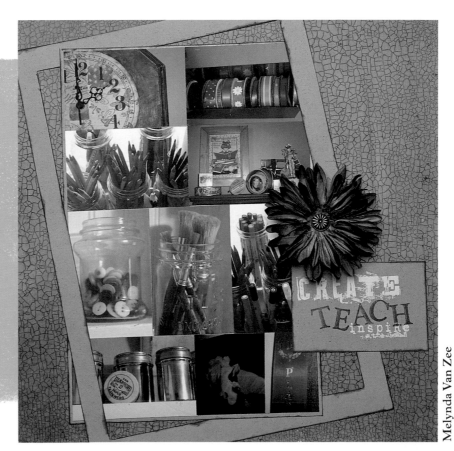

Melynda Van Zee

China Crackle Box Variation

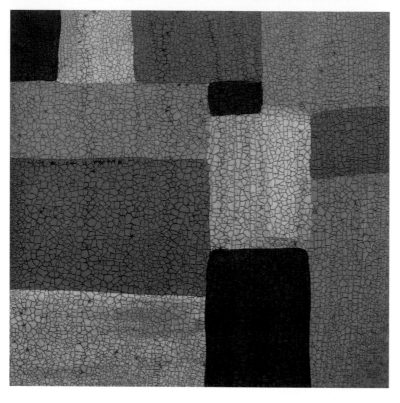

You can also apply china crackle directly over any multi-colored painted background for an instant aged look. For this variation, first paint purple and green rectangles on the page using acrylic paint. Allow the paint to dry, then apply step 1 and step 2 of the china-crackle medium. For the final step, rub antiquing gel or brown paint into the delicate cracks.

*S*ince *rectangles form the foundation of this design, I decided to repeat the shape throughout the layout. I cropped the photos and cut the chipboard elements into rectangles for placement on the page.*

Melynda Van Zee

Weathered and Broken Crackle Variation

Create this weathered look by randomly drybrushing brown acrylic paint on tan cardstock. Apply step 1 and step 2 of the china-crackle medium only over the areas you have dry brushed. To accentuate the crackled design, drybrush white acrylic paint over the background and into the tiny cracks.

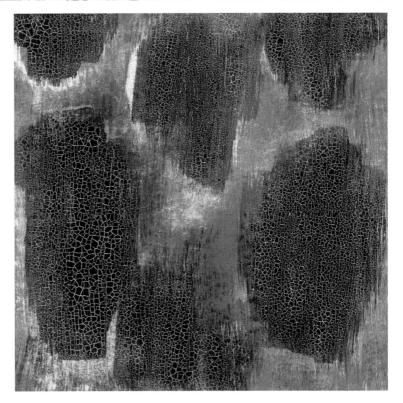

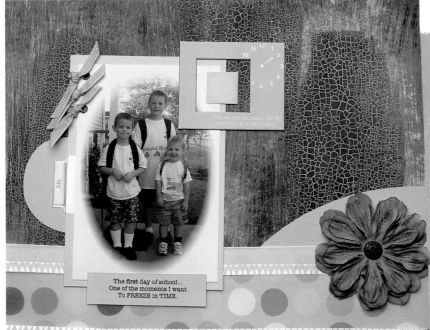

Melynda Van Zee

The first day of school... One of the moments I want To FREEZE in TIME.

The weathered look that came from this technique reminded me of the passage of time and how important it is to capture moments when we can. Using a black and white photo with a soft oval bleed reinforced the emotion I wanted to convey. Little things make a big impact in this design. I selected a bronze metal brad to attach the flower to the page. Think about the color of the metals that you select to use on a page—would a silver brad have the same visual affect?

Imagine your page with ready-made journaling

Masking

boxes, painted photo mats, or color-blocked sections. All of these great scrapbook design elements can be created with painter's tape! This marvelous tool is affordable, comes in all different widths, and can be applied in hundreds of ways to create built-in designs for your pages. You can use traditional-width low-tack painter's tape or the new thin-line low-tack tape found in any hardware or home-improvement store.

Masked Rays

Like Stickers on page 29, this is a resist technique. Wherever you put the tape, the paint won't go. Any design you can make using straight lines can be made with masking tape. To give this paper interest, I placed the masking tape close to one edge, and partitioned the paper into rays that I could fill with paint.

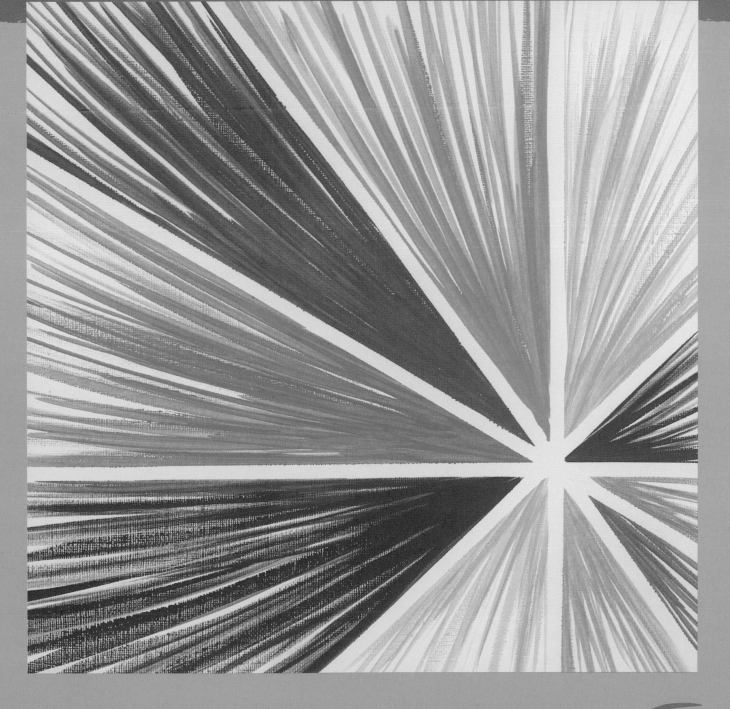

Materials & Tools

Thin, low-tack masking tape

Light yellow cardstock

Assortment of pastel colors of acrylic paint

Flat paintbrush

Instructions

1 Section off the paper by applying tape to the cardstock in a radial design.

2 Using the side of the flat brush to paint thin lines, sweep each color of your choice across the newly created sections of the paper.

3 Carefully remove the tape, taking care not to pull up pieces of the cardstock as you go.

Black and White Frame Variation

This large box is perfect for featuring an oversized photo. To make the box, begin by criss-crossing strips of thin, low-tack tape on a sheet of textured cardstock. Then, dry brush black paint over the tape. Allow the paint to dry before removing the tape to reveal the frame.

Ladder Variation

Experiment with interesting placement of the masking tape. Several strips of tape and a bit of black acrylic paint on this orange cardstock were all that were necessary to create this ladder. This design element makes a great place for adding a border of photos to your page.

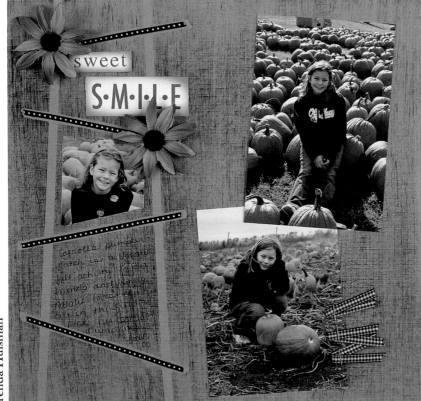

Brenda Huisman

The rungs of the ladder made by this masking variation are perfect spots for placing a title, photo, or a bit of journaling. Ribbon is always a great way to add emphasis to your painted elements—notice how the black and white polka dot ribbon draws your eye right to the ladder.

103

Off-the-Wall Paint Techniques

Paper ✓

Plastic Wrap ✓

String ✓

Get ready to create with abandon. Prepare yourself to crumple, fold, press, scrape, and pull like you never have before. Yes, you might even get your fingers dirty. These experimental projects are unconventional and just a little bit wacky, but they're guaranteed to bring out the child in you. In fact, these projects would be great fun to do with a child.

Manipulated Materials

The following techniques are created by manipulating the materials you'll use to make the effects—the most important tools will be your own hands. You'll find that crumpling, folding, and pressing can yield some surprising results.

Crumpled Paper

I hate to iron. I admit it—I'd rather be painting or scrapbooking than removing wrinkles. However, this is one project where wrinkles are welcome because they'll give your painted page character. Since the paper needs to endure the wrinkling and crinkling you'll do to get the look you want, use a heavyweight cardstock or watercolor paper for this technique.

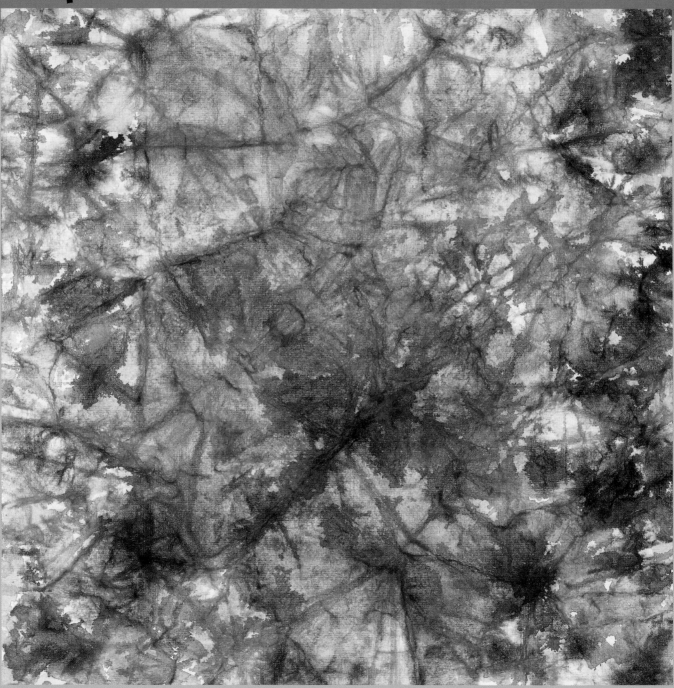

Materials & Tools

12 x 12-inch (30.5 x 30.5 cm) sheet of watercolor paper or heavyweight cardstock.

Cranberry acrylic paint

Paintbrush

Instructions

1 Using your hands, crumple the white cardstock into a large ball.

2 Wet the crumpled paper in a large container of water or a sink. It's not necessary to soak the paper, just dampening it will be fine.

3 Smooth the paper out as flat as possible, being careful not to tear it.

4 Thin the paint with water. Use the brush to drip random pools of paint on the surface of the paper, allowing the paint to bleed into the creases.

5 Crumple the paper again, flatten it, then add more pools of color as needed to make the paint bleed over the page. Look at the paper carefully to decide which areas may need more color.

6 Flatten the paper with your hands as much as possible, and allow the paper to air dry.

7 Once the paper is dry, lay a scrap piece of cardstock over the paper and place a heavy album on top to flatten.

Pressed Paper

I remember the painted butterflies I made as a child by folding a piece of paper in half, and then pulling the paper apart to reveal my creation. I may be all grown up, but it's still fun to drizzle, press, and pull. Since you make two pages using this technique, you'll find the coordinating designs are perfect for creating layouts with facing pages.

Materials & Tools

Deep red and white acrylic paint

Plastic cups or containers

Palette knife

Plastic spoon

2 sheets of maroon cardstock

Rubber brayer (optional)

Instructions

1 Pour the paint into two separate small plastic cups or containers. Thin each color with a small amount of water.

2 Using a plastic spoon, drop both colors of paint in a random design over one sheet of cardstock. Don't worry about the colors touching or overlapping—when you press the paper, those areas will mix to create great new colors.

3 Lay the second piece of cardstock directly on top of the painted cardstock. Press firmly with your hands or rubber brayer. Gently peel off the top piece of cardstock.

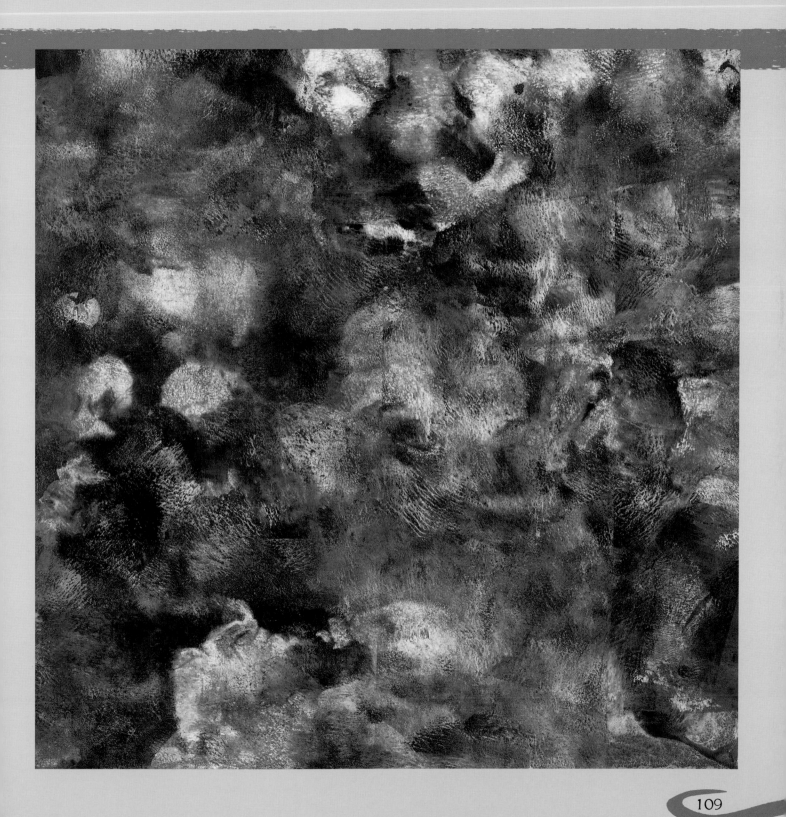

Plastic Wrap

This technique is a cousin to Rag Rolling (see page 82). The crumpled plastic wrap removes some of the paint, but also moves it around to create beautiful textured patterns. As you experiment using plastic wrap, you'll find that you can never predict the lovely designs you'll create.

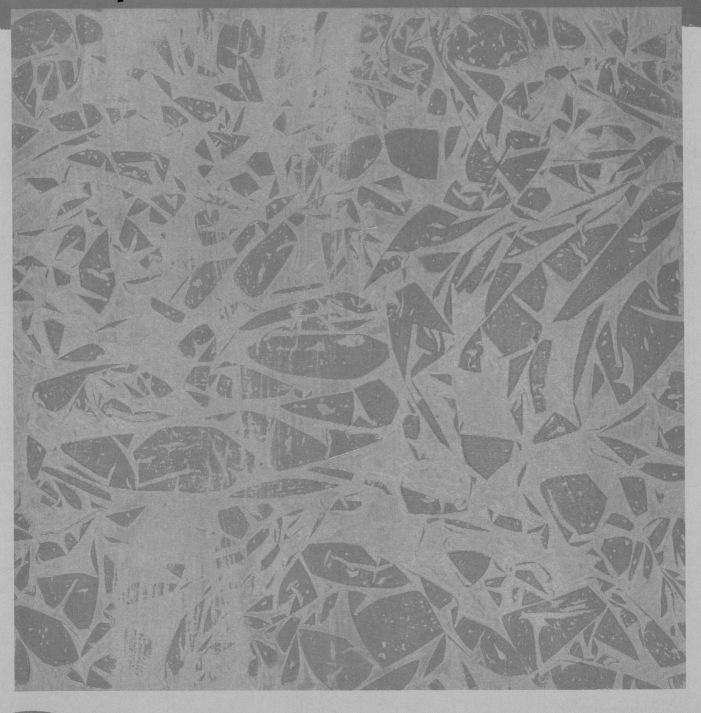

Materials & Tools

2-inch (5 cm) flat paintbrush

Gold-flecked olive green cardstock

Metallic green acrylic paint

Plastic wrap

Instructions

1 Use the brush to paint the cardstock with water. Cover the entire page, making sure you don't leave any pools of water on the surface.

2 Thin the paint with water. Quickly paint the cardstock with the brush.

3 Take a large piece of plastic wrap, one that is at least twice as long as the cardstock, and scrunch it into a ball. Open it, and lay it on top of the painted cardstock.

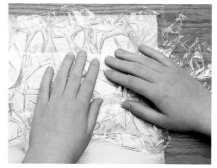

4 Using your hands, press the plastic wrap onto the cardstock, making sure it covers the entire surface. The wrap should remain wrinkled and bumpy.

5 Allow the cardstock to dry two hours before removing the wrap. Keeping the wrap on the cardstock holds the paint in place while it dries.

Just as the boy moves in and out in of the shadows in his game of peek-a-boo, the subtle texture of this faux technique plays across the page. The tone-on-tone effect on the paper was made by using a metallic paint that is close in value to the color of the cardstock.

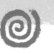

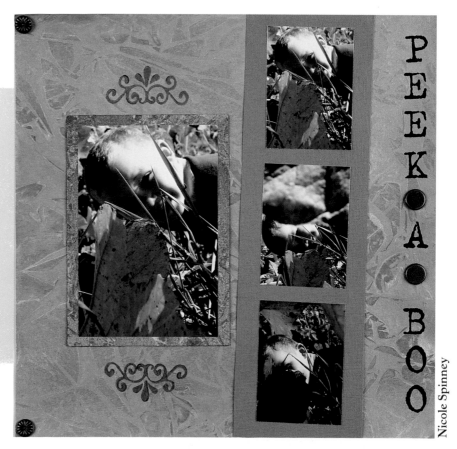

Nicole Spinney

Folded Paper

In this technique, paint pools into the creases of folded paper to create a soft-edge grid pattern. Instead of paper I used a sheet of spun olefin—it's a product very similar to the protective covering that wraps houses under construction. Because it has a slick coating on one side, the spun olefin creates an amazing texture when the paper is pressed together and then pulled apart.

Materials & Tools

12 x 12-inch (30.5 x 30.5 cm) sheet of spun olefin

2-inch (5 cm) flat paintbrush

Metallic gold and black acrylic paint

Round artist's brush

Instructions

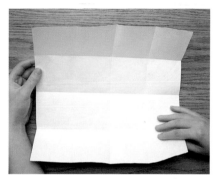

1 Fold the sheet of spun olefin into 16 equal squares and then unfold.

2 Paint a coat of metallic gold acrylic paint over the entire surface.

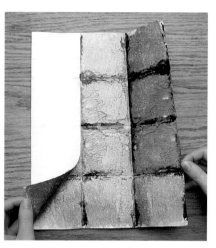

4 Refold the paper along the original creases. Open the paper, and then fold again. Keep opening and folding until you are satisfied with the design. The pattern will change and develop with each new fold.

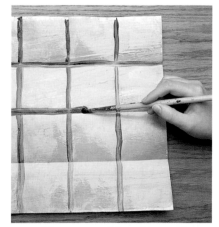

3 Use a round brush to paint a line of black paint along each crease.

You never know what results you'll get from the folded-paper technique until you open the painted page. In much the same way, you never know what inspiration will come to you for a layout until you begin working on it. The texture of the page reminded me of the bricks in a photo I had of my great-great-grandfather's home in Holland. I used the flip side of the journaling block to tell the "other side of the story."

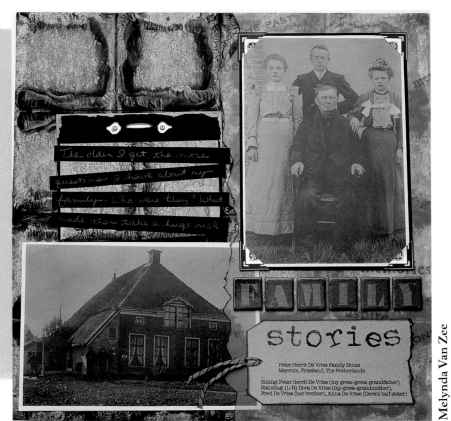

The older I get, the more questions I have about my family. Who were they? What made them take a huge risk

FAMILY stories

Peter Gerrit De Vries Family Home
Marrum, Friesland, The Netherlands

Sitting: Peter Gerrit De Vries (my great-great-grandfather)
Standing: (L-R) Dora De Vries (my great-grandmother),
Fred De Vries (her brother), Anna De Vries (Dora's half sister)

Melynda Van Zee

Grandma told me that Dora's mother died when she was 2 or 3 years old. She left Dora and her brother, Dora's dad (my great-great-grandfather) remarried and had 5 children with his 2nd wife. This made Dora and Fred step-children and according to grandma there was no love lost for the "1st wife's children". At age 21, Dora's father bought her a new dress, paid for her ship passage to America and in Grandma's words said, "Now go, I don't want to see you again." Dora sailed to the US, married Gerrit De Boer and raised her family. My grandma has told me that her mother was a harsh and difficult woman. Now, at 52 I understand why. I understand so much more about my own grandmother with this one story. Family stories are a powerful thing. I'm sorry it took me so long to ask.

Dec 2006 Melynda

114

Too-Easy Tools

Palette knife, strings, fingers. Sound simple? These too-easy tools may seem unconventional. Just remember— it's your time to experiment.

Pulling Strings

Have you ever had one of those days when you felt you were being pulled in all directions. If so, you'll have fun when you're the one pulling the strings in this technique. These wacky designs make great backgrounds for all those silly kid photos. You might even want to have your kids help create these papers—it's perfect back-yard fun for a sunny afternoon.

Materials & Tools

Peach, turquoise, lavender, and blue acrylic paint

Foam plate or plastic lid

4 pieces of string, yarn, or fiber cut into 15-inch (38.1 cm) lengths

2 sheets of white cardstock

Wooden spoon or rubber brayer

Instructions

1 Prepare the paints by thinning them with water. Pour a pool of each color onto a foam plate or plastic lid.

2 Drag one piece of fiber or string through the first color of your choice.

3 Lay the string loaded with paint in a wavy pattern on white cardstock. Leave at least 1 inch (2.5 cm) of string trailing off the edge of the paper so you have a handle to pull when removing the strings.

4 Load each of the remaining strings with a different color. Arrange them randomly on the same piece of cardstock.

5 When all strings are in place, put a second sheet of cardstock on top of the bottom sheet and strings.

6 Rub your hand, a wooden spoon, or a rubber brayer over the top of the cardstock.

7 Placing one hand on the top cardstock, use your other hand to pull the strings from between them. Remove the top sheet of cardstock to reveal your design.

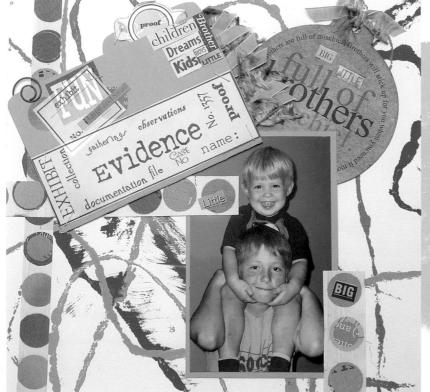

Melynda Van Zee

Some scrapbook pages are quiet and some are not. For some layouts, the phrase "less is more" just doesn't apply. The bold, bright, and layered look of these embellishments only heightens the wild and wacky nature of this technique. The file folder becomes a fun place to hide some journaling.

Palette Knife

Usually artists use palette knives to mix paint. However, they're great painting tools in their own right because they can create fabulous textures that are impossible to achieve with a brush. Palette knives are made of plastic or metal and come in a variety of different shapes—you can find them with thin tips, wide tips, straight handles, or crooked handles. Since different tip widths create slightly different looks, experiment to find one you like.

Materials & Tools

2-inch (5 cm) flat paintbrush

Lavender and dark purple acrylic paint

White cardstock

Paint tray

Palette knife

Paper towels

Instructions

1 Using the paintbrush and lavender paint, create your base coat by covering the cardstock with a thin layer of paint. Allow the paint to dry.

2 Pour a pool each of lavender and dark purple acrylic paint onto a flat paint tray. Dip the bottom edge of the palette knife into the color of your choice.

3 Hold the palette knife perpendicular to the cardstock as you apply the paint. Stroke up and down the paper as if frosting a cake. Clean off the palette knife with a paper towel.

4 Dip the palette knife into your other color, and apply it in the same manner, overlapping the first layer of color. Add more paint as needed until you have the blended look you desire. Clean off the palette knife with a paper towel.

5 Using the tip of the palette knife, scrape off sections of the top layer of wet paint to reveal the lighter base color underneath.

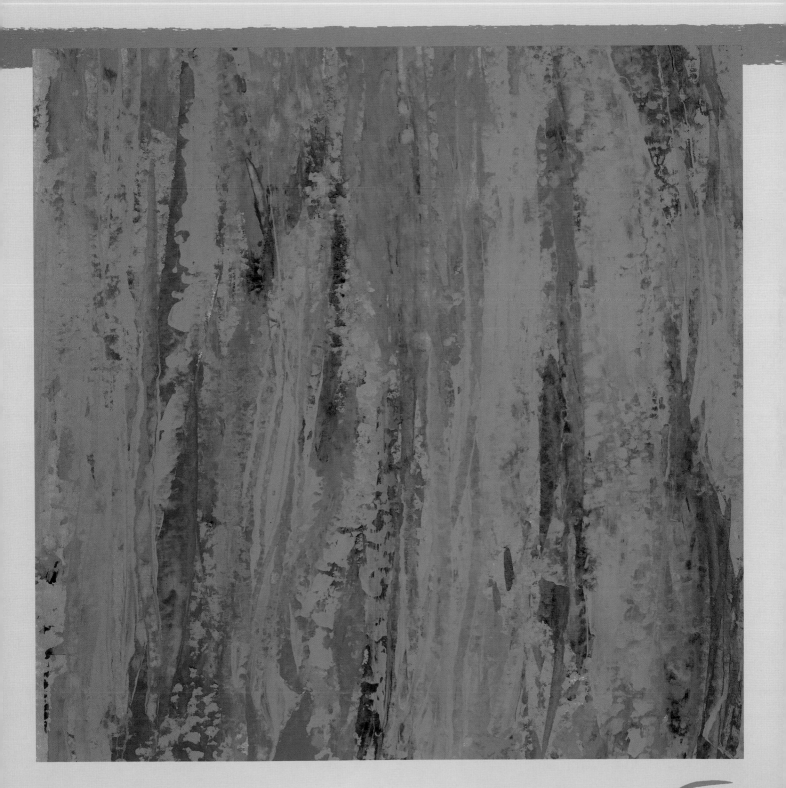

Finger Painting

Throw away your inhibitions. How long has it been since you used a humble finger to create a masterpiece? As adults, we seem to forget that one of the best painting tools is as close as our hands. While it may be a bit messy and take a bit more time, there is nothing quite so satisfying as the tactile experience of using your fingers to manipulate paint.

Materials & Tools

Foam plate or plastic lid

Sage green, lavender, and white acrylic paint

White cardstock

Paint tray

Instructions

1 Pour a pool of each color onto a foam plate or plastic lid. Dip your index finger into the lavender paint. Apply random strokes in an X pattern on the white cardstock. In order to make sure you cover the whole surface, make some of the Xs disappear off the edges of the paper. Allow the paint to dry.

2 Use your finger to paint more Xs with the sage green paint. Overlap some of the lavender Xs and fill in the empty spaces on the design. Allow the paint to dry.

3 Using the white paint, repeat, making Xs over the lavender and sage green Xs until you are satisfied with the design.

The exuberant freedom expressed through this technique, matched with the fresh, spring color palette, creates a wonderful background for these lovely outdoor photos. Designer Angela Biggley added touches of pink at just the right places on the page. Notice how the pink flowers entice your eye to encircle the photos before focusing on them.

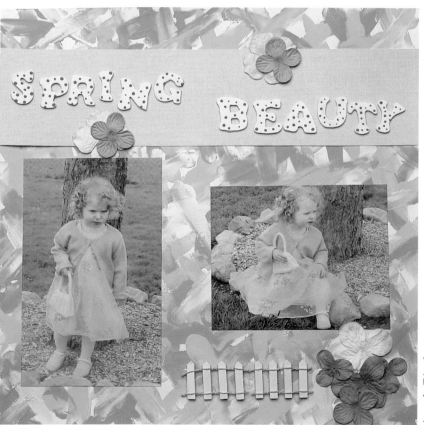

Angela Biggley

121

Acknowledgments

To my husband Brian, a wise and talented business mind, who has believed in me from the very start. Even though he doesn't particularly love "art," he loves me, and that is what is supremely important. He was the one who ultimately pushed me out of the studio and into the world by convincing me, "I don't invest in junk."

Hugs and love to my three boys. You are the sunshine in my life and the reason I get up every morning. Your smiles, joys, triumphs, and messes spur me on to grab my camera in the quest to record and treasure our life together. You inspire me, you invigorate me, you exhaust me, and I love you all!!!

To my mother, who was the first person I called to tell, "I'm writing a book." Her encouragement, positive thinking, and creativity have nurtured me into the woman I am today. And to my father, who taught me by example the power of story, and instilled in me the value of education and teaching.

To my Scrapbook with Passion team— Brenda, there are not enough words to say just how thankful I am for our friendship. Your creativity, help, opinions, organization ("Have we got our 3,000 words in today?"), and teaching skills are lifesavers for me each and every day. Erin, your graphic-design skills amaze me. I wouldn't be where I am today without your guidance.

To my Book Club—I'm sure this book will be the first non-fiction monthly reading selection in the history of the BCBC. Thanks for serving as my focus team and support group all at the same time.

To my family and friends—You are the best; always encouraging me, supporting me, inspiring me, and helping me with all the craft, art, child-rearing, cooking, and marriage questions I dream up.

To my students—So many of these projects were researched while in the process of planning projects to teach and dazzle you with what you could create with simple tools and paint. Thanks for pushing me to be the best teacher I can be.

To my art teachers—You taught me by example about watercolors, oils, acrylics, photography, drawing, color, and design. Thanks for inspiring me, challenging me, and leading the way with integrity and purpose.

To the designers who contributed to this book—Thank you for sharing your beautiful and personal creations.

To the amazingly talented and professional team at Lark Books—Thanks, Terry Taylor, for discovering me and recognizing the potential in my work. Suzanne Tourtillott and Jane LaFerla, my editors, you amaze me with your organization and attention to every detail. Carol Taylor, thank you for your vision. I was deeply honored and encouraged when you believed in me enough to say, "This book needs to be written and you are the only one who can write it." And, to the art team who photographed my paintings and designed the beautiful layout of this book—I am in awe.

Contributing Designers

Maranatha Baca spends her spare time designing pages, creating altered-art projects, and taking pictures. She and her wonderful husband are enjoying small-city life as they both raise their darling son. Maranatha first learned about scrapbooking while pregnant with her son—since then, it has been a non-stop hobby. Designing layouts has led her to pursue her interest in photography. Her true passion is to continue creating art through photos and paper.

Brenda Huisman has been consumed with the passion to scrapbook for as long as she can remember. She currently teaches professional art and preschool, and is the creative art director for Scrapbook with Passion. With her expertise in innovative layout design, she serves as a teacher and consultant for independent scrapbook retailers. Brenda lives in Iowa with her husband Nathan, daughter Natalie, and sister Amanda.

Tanya Mundt says she's always been creative. She became instantly hooked on scrapbooking when she was pregnant with her first child. While she finds design ideas everywhere, she says her children are her greatest inspiration. Tracy is on an on-line design team at www.starmosaics.com. She teaches scrapbooking, and says her next goal is to be part of a design team for a magazine.

Netalia Riggle, from Charlotte, North Carolina, is a stay-at-home Mom who features her two-and-a-half-year-old son, Haydn, as the subject of most of her photography. She teaches scrapbooking, and has designed for various publications and design teams. She enjoys being with her family, scrapbooking, photography, shopping, and decorating. Great photos inspire her, but also patterns, colors, and clothing.

Rita Shimniok lives in Wisconsin and has worked more than 20 years as a graphic artist. Through the years, Rita has enjoyed many crafts, including quilting, but discovered her true passion, scrapbooking, in 2003. For Rita, the art of scrapbooking combines all of her creative gifts, which include writing, working with color, and photography. She has had several works published and plans to someday write a book of her own.

Nicole Spinney, from Brewer, Maine, has been scrapbooking for several years and enjoys making scrapbooks for family and friends. She pursues many crafts including knitting, making homemade gifts and decorations, and doing craft projects with her daughter. Having grown up in Maine, Nicole enjoys everything her state has to offer, including fall days when the leaves are changing and the pumpkin patch is ripe for picking.

Index

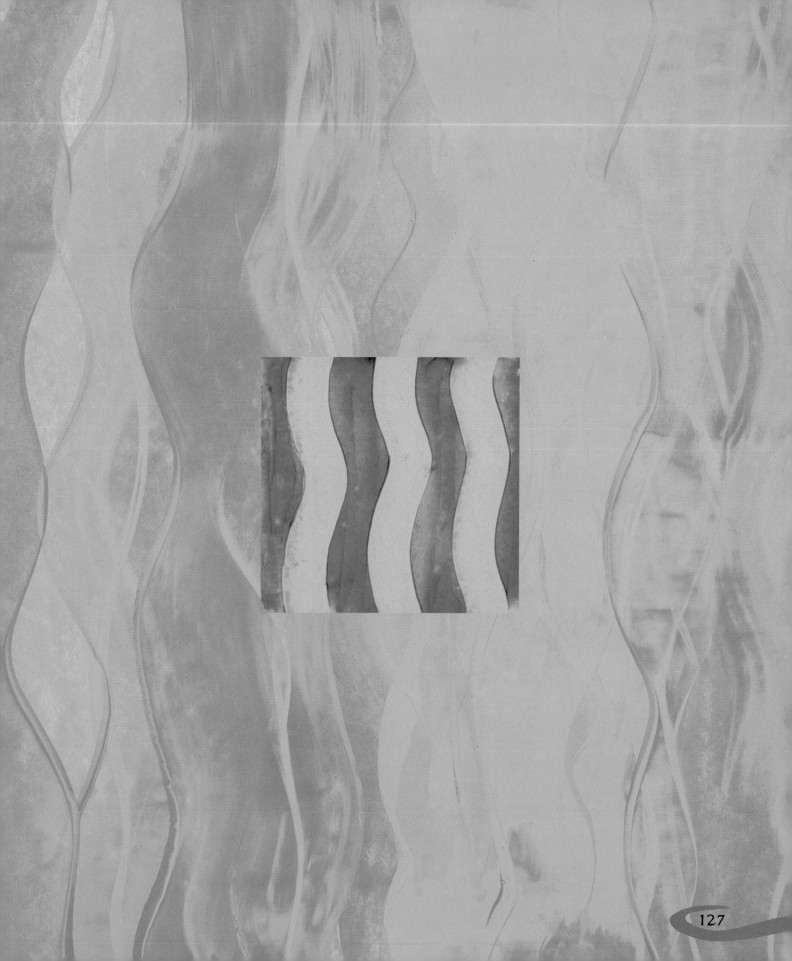